HAUNTED AUSTIN

HAUNTED AUSTIN

HISTORY AND HAUNTINGS IN THE CAPITAL CITY

JEANINE PLUMER

Haunted America

Published by Haunted America

A Division of The History Press

Charleston, SC 29403

www.historypress.net

First published 2010

Manufactured in the United States

ISBN 978.1.60949.040.9

Library of Congress Cataloging-in-Publication Data

Zeller-Plumer, Jeanine Marie.
Haunted Austin : history and haunting in the capital city / Jeanine Marie Zeller-
Plumer.
p. cm.
Includes bibliographical references.
ISBN 978-1-60949-040-9
1. Haunted places--Texas--Austin. 2. Ghosts--Texas--Austin. I. Title.
BF1472.U6Z44 2010
133.109764'31--dc22
2010028133

CONTENTS

INTRODUCTION

Initially when I decided to start a walking tour company in Austin, my intention was to give tours about Austin's unique history. While researching the old buildings downtown, the building occupants would mention with surprising frequency unexplainable events taking place that they attributed to a ghost. I would nod my head and pretend to listen, but really, I had never thought about ghosts in my life. Still, every now and then, on a tour I would mention that the building dwellers believed they had a ghost. When I mentioned that, the people in the tour group invariably lit up with interest. It became obvious: they wanted to hear ghost stories! It was then I decided to collect Austin's ghost stories and create a ghost tour.

Of course, the first question to ask is who is haunting the building? It came to my attention that pretty much everybody believed their ghosts came into existence through some sort of drama. Each suicide or murder seemed to be over lost love. Every building was, at one point, a brothel or bordello, a speakeasy or gambling hall. Austin's colorful famed gunfighter Ben Thompson was haunting every bar in the city. What ended up floating around with the ghosts were lots of urban legends, no real facts.

If I was going to tell Austin's ghost stories, I was going to tell the real story. After all, we don't *really* know what is happening, but perhaps by telling the truth I would stay on the good side of the spirits.

What I discovered, of course, changed my life. Whatever you want to call these energies—ghosts, spirits or souls—they seem to be remnants of people who have lived, died and continue to reside. Why they choose not to leave, or whether they're unable to, we don't know.

What you believe is your choice, but I can tell you without a doubt that there is something happening around us everywhere—barely discernible, but very much there. After interviewing hundreds of people, it is clear what ghosts can do is astonishing. They can turn lights on and off along with televisions, cell phones, fire alarms and water faucets. They can open and close doors, windows and shades. They can move objects of all sizes, make phone calls, move furniture, knock on doors, ring doorbells and even talk to you. These occurrences are just some of the phenomena taking place in Austin's buildings populated by the living and other-worldly beings. Point to ponder: a majority of people who experience what they believe to be a ghost do not feel fear.

When researching who these people might have been in life, I soon discovered that the residual energies that remained were not famous Austinites—the infamous or those who were "bigger than life" in any way. The spirits that remain are regular people, like you and me. It is the woman who was widowed at a young age and opened a millinery shop on Sixth Street to support herself and her children; every morning, for much of her life, she sent her kids to school and went downstairs to open her business. Some part of her spirit is still doing that. It is the man who began working as a porter at the Driskill Hotel at age sixteen, the fourth generation in his family to do so, tending to guests into old age and beyond. It is the woman who entered the Confederate Women's Home when she was sixty-five years old and died there

at the age of ninety. Every day for twenty-five years she walked the hallways—and still does today.

My concluding belief is most ghosts remain because of life. The life they lived makes a stronger imprint than the process of their death.

CHAPTER 1
FLOOD VERSUS FAMILY

From the onset, the swollen motionless clouds that had settled over Austin were ominous. Massive storms had been moving through the central Texas region since Friday, April 6, 1900. In some areas, as much as seventeen inches of rain had fallen in only two days. Water poured from creeks and tributaries into the Lower Colorado, causing its waters to rage as it swelled the shore limits of Austin's popular retreat Lake McDonald and sent a steady current over the wall of the Great Granite Dam.

The dam was a source of great pride for the city, gracing the cover of *Scientific American* magazine. In 1890, bonds were sold to cities in the east and $1 million was raised for the construction of a dam and $600,000 for a power plant. The dam was completed in 1893, and the waters it held back formed Lake McDonald. But despite its praise as an engineering marvel, not everyone agreed. In 1896, the mayor received a letter from Mr. Frizell, the chief construction engineer who was forced to resign during the construction of the dam, warning that there was a problem with the construction on the east side of the dam. In 1897, a fisherman noticed a six-foot-long hole beneath the dam. In 1899, a leak was discovered on the east side of the dam; it was patched with clay. Then, in early April 1900, the rain began.

The torrential downpour began in earnest late Friday afternoon, April 6, and continued. "All night long the rain fell in solid sheets," reported the *Daily Tribune*. City residents knew to stay away from low water crossings and infrequently traveled dirt roads. Once the rain commenced mobility in and around the city was quickly limited to foot traffic or horseback. Scheduled meetings for groups such as the Cigar Makers Union, the Austin Garten Verwin, Pashahona Tribe 19 and the ancient Order of Hibernians were postponed.

Finally, on Saturday morning, April 7, the rain stopped and, with the dawn, only a few clouds and light drizzle remained. By midmorning, the sun had begun to shine, and some Austinites ventured out to work or play. But many more chose to make the trip along Dam Avenue, two miles west of downtown.

Word had spread rapidly through the city that the raging water around the dam was a sight to behold. The water had risen eleven feet above the dam's summit and was cascading down in a wild torrent. Anxious to see the impressive sight, no one questioned the stability of the 60-foot high, 1,150-foot-long and 60-foot thick concrete and granite structure.

At 11:15 a.m., a shock rumbled like a smothered explosion, echoing for miles throughout the Hill Country as the dam split down the middle and the east side crumbled under the water's pressure, washing away. Below the dam, a fifty-foot wall of water descended as the thirty-mile-long and one-mile-wide Lake McDonald emptied into the already swollen Colorado.

Austinite Neal Begley said, "I saw the water spread out and everything seemed to go down at once."

As the dam began to shatter, Henry Robell was quick enough of mind and limb to move faster than the swirling wave. Upon witnessing the first movement of the shifting massive structure, he did not wait to see what would happen but raced on horseback at breakneck speed along the Colorado's northern bank into the city, warning people and saving lives as he shouted, " The dam has broke! Run to high ground!"

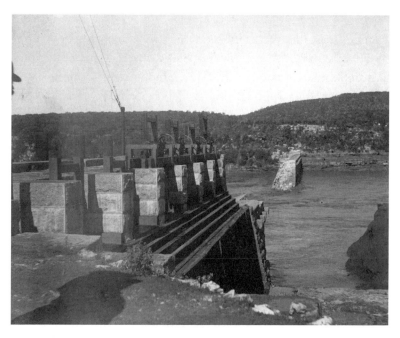

What remained of the dam after April 7, 1900. *Courtesy of the Austin History Center.*

The president of the Austin Telegraph Company, O.D. Parker, within minutes of hearing Robell's warning, quickly mounted his horse and rode to his office on Congress Avenue where he frantically telegraphed to the towns scattered downstream of Austin, "Dam has broke!" Those within earshot of the warning scattered. Some people rushed to save what they could from their homes. Others galloped on horseback along the riverbanks, warning neighbors. Many of the rural people living on or close to the river's shore could not be reached in time. The number of lives lost cannot be accurately determined.

"Men, women and children were screaming and crying and people were running as if mad in all directions," one man would later describe.

A reporter watched as the water swept seven houses downstream. The passenger depot at Third Street and Congress

Avenue was engulfed; the lumberyard that stretched from the river's north shore beyond Second Street incurred total destruction, as did the Austin Ice Company at Congress and First Street. The Metz Brothers, Albert Schneider's and Otto Schulenburg's saloons on the east side of the city in the German district were also destroyed. Water pushed up Congress Avenue, flooding the first floor of businesses as far north as Ninth Street. People camped along the shores were carried away, joining the houses, cows, dogs, farm equipment and other victims caught in the rushing waters. The river continued to rise seventeen inches an hour until 3:00 that afternoon.

Witnesses cheered as a man climbed a telephone pole just before the wildly swirling water reached him. The cheers faded into horrified gasps when he was suddenly struck by a house caught in the deadly current.

The *Austin Daily Statesman* reported, "Austin resembled a bed of red ants suddenly disturbed. Men and women run hither and thither in the wildest alarm. Carriages, buggies, horsemen, and cripples were rushing down toward the river and every newcomer had a fresh tale of horror to tell."

Shoal Creek and Waller Creek rose twenty feet in two hours. The homes and businesses of the African American and German communities scattered along the shores of Waller Creek and the predominately Anglo homes lining Shoal Creek were consumed with water.

Alerted, some families were able to gather their children and, in some cases, their livestock before their homes were destroyed. Other families escaped onto the roof where they remained stranded until after nightfall when volunteer rescue teams in boats carried them to solid ground. Some, like the Italian family whose house was just below the dam, never had a chance. They were never seen again.

At the site of the dam, five hundred people had lined up along the limestone walls and shores to watch the enormous amount of water that Saturday morning. Other thrill seekers were standing

below the dam, witnessing the awesome sight from that imposing vantage point. When the granite wall gave way thunderously and the massive structure began to crumble, some spectators gathered below were able to move quickly enough, avoiding the deluge by climbing trees and the sloping hillsides. Others were swept away in seconds.

The *Austin Daily Tribune* somberly reported:

> *Five young men were taking Kodak pictures below the dam when the break occurred and all were drowned. Their names could not be learned...*[A] *woman and two children were seen floating down the river a short distance below the dam. The woman was said to be wearing a red dress. Still another young mother was unable to move her four children to safety in time and they found themselves in the rushing water's path. In Austin their bodies were seen floating down the Colorado River.*

In the hydroelectric plant just below the dam, six men and three boys were working in the bottom of the powerhouse, pumping out leaking water. All drowned but one man who was able to throw his belt buckle over a piece of metal protruding from the ceiling, pulling himself above the water. Two of the boys were brothers, found by the Austin Fire Department trapped beneath one of the generators. They were still embracing as they had been when water filled their lungs.

When the water subsided, onlookers peering into the powerhouse were able to see the bodies of the remaining workers swirling, trapped in a whirlpool. The water was still too high and the current too strong to attempt a rescue. The next day, family members watched as dynamite was set against the outer wall and a hole was blasted, allowing the bodies to escape.

The dawn of Sunday morning, April 8, 1900, would find hundreds of homeless people camped on the hills surrounding the city. Those with homes opened their doors and welcomed as many as they could. Women cooked all day to feed those left with only the

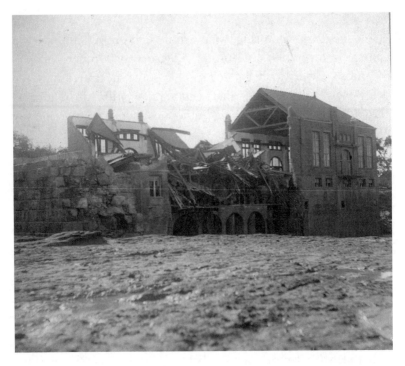

The Powerhouse after dynamite was used to free the bodies of the drowned men and boys. *Courtesy of the Austin History Center.*

clothing on their backs. The men spent all night and the next day running boats up and down the canals rescuing those that had been strong and secure enough to wait precariously above the waters. Texans living in outlying towns and homesteads loaded their wagons and brought all the food and supplies they could afford.

In addition to the immediate problems of shelter and food, there were other potential calamities, such as cholera, malaria and typhoid fever. The water treatment plant was flooded by fifteen feet of water. All of the city's drinking water was contaminated. Officials began making public speeches and walking from door to door, warning Austinites not to use old or stagnant water or to drink from wells that had previously been in disuse. Fortunately in 1900, some artesian springs still flowed freely in the city and

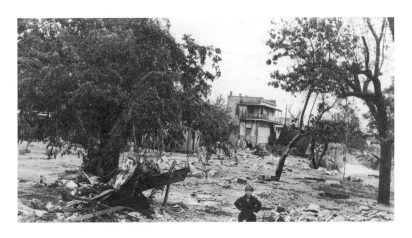

The Hofheintz-Reissig building is all that remains of what used to be a neighborhood. *Courtesy of the Austin History Center.*

long queues quickly formed. Fear of fire was also in the forefront of the minds of city leaders. The neighboring cities of Houston and San Antonio responded within twenty-four hours and sent five fire trucks on the railroad.

Stories of tragedy and greatness arose in the days that followed as the city pulled itself together. The dead were buried, homes rebuilt. Once again, the customary sunshine beat down on the whitewashed boards and limestone buildings. The breeze from the flowing river stirred the dust along the unpaved roads. But the wall of water would not soon be forgotten. Residents continued to walk or ride along Dam Avenue. They went to look, to remember, to imagine. They could see the great pieces of concrete that had been tossed like pebbles and scattered below what remained of the dam. Clearly visible was the shell of the building that once held Austin's powerful generator, providing water, electricity and transportation for a city of more than thirty thousand. A placid retreat for boating and picnics, Lake McDonald was the first artificial reservoir in the state. It spread a mile wide from shore to shore and was a place where many residents had summer homes. Lake McDonald was now gone.

After April 7, 1900, it was morbid curiosity that drove people to the vanished lake. Often young boys and girls, now with little to do on the hot summer nights of 1900, would take the walk along Dam Avenue just to look at what was once their lake. It was on these nights that rumors of lights shining from beneath the water began.

Older residents of Westlake Hills just to the west of the city remember going at night to what is now Red Bud Island when they were kids. They would say they were going night fishing, but they were always looking for the lights coming up from the water. "We'd get real quiet after our lines were cast. We weren't really interested in the fish. Whatever we caught we threw back in. We were looking for the lights." One Westlake homeowner remembers, "You would see them one in ten times. Usually there was one light but sometimes two or three. The lights were round and clear, and they moved around on the surface of the water. They came from under the water."

Similar lights have been seen around Waller Creek, south of Fourth Street, at the junction where Waller and the Colorado meet. This was where the wave of water took its greatest toll.

HOFHEINTZ-REISSIG BUILDING—MOONSHINE PATIO BAR & GRILL

At the corner of Third Street and Red River stands the Hofheintz-Reissig building, a testimony to the durability of German stone architecture. After the wave of water wiped out virtually all of their neighbors' homes, the Hofheintzes and Reissigs were surely a part of the team of families who cared for the homeless and grieving.

German native Henry Hofheintz purchased the property in 1854. At the time he was a widower but soon married Christiana Hinemann. What is today called the Sunday House was the first stone building on the property. It was used to keep the food for

Hofheintz's mules dry. His mules were paramount to his livelihood because he drove his springboard wagon to and from Mexico buying, selling and trading goods. Eventually, the Carriage House and the main structure were built, serving as store and home. During the Reconstruction Era following the War Between the States, the Sunday House was used by freed slaves who needed housing. The cellar stored wine made from grapes grown on the property, and during the hot summer months it provided a cool place to play dominoes. The Hofheintz-Reissig building was a store, biergarten and restaurant for 112 years before the family sold it in 1966.

Mrs. Hofheintz was living on the property when she died fourteen years into her marriage. Henry himself passed on in 1880 while proprietor of the Hofheintz grocery store. His daughter, Catherine Louisa, married Adolf Reissig, a native of Germany, and they lived, worked and eventually died on the property. Their son Herman married Eula Petry, and they lived and worked on the property, along with her family, until he died

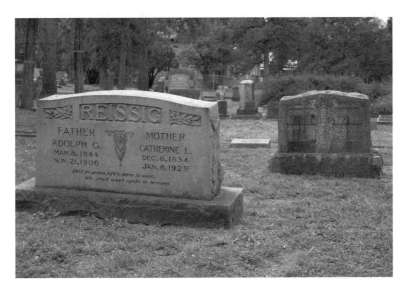

The Reissig family is buried in a family lot in Oakwood Cemetery. *Courtesy of John Maverick.*

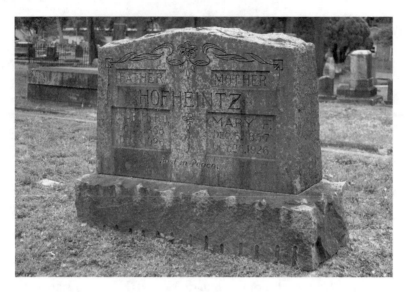

The Hofheintz family is buried in Oakwood, the Austin city cemetery. *Courtesy of John Maverick.*

in 1961 with Eula following in 1962. Even though some may have died in a hospital or infirmary, wouldn't their greatest attachment on this earth be to the place they all spent most of their years? That might account for the strange occurrences reported at the Hofheintz-Reissig building. Or are the proprietors still welcoming others even as residents of the spirit world?

The current owner of the building claims that most of the strange activity in the building is reminiscent of a child or children who demand attention from the staff and customers at Moonshine Patio Bar & Grill. There was the time he was in the office upstairs trying to print something from the computer without success; he shut down the printer and computer as he was leaving the office, and just as he snapped off the light the printer tray flew halfway across the room at him. Unimpressed, the proprietor calmly chided the ghost, saying, "No, no. No more of that, now. I'm going downstairs!" And he left.

In 2009, staff members were gathered in a booth, wrapping silverware in napkins and preparing for what they hoped would

be a busy Thanksgiving weekend for Moonshine. As they were chatting about how they spent their Thursday holiday, an ill-tempered spirit, perhaps upset that the restaurant was closed the previous day, yanked an entire tray of glasses from the wait station nearest them, shattering the glassware.

Glasses seem to be convenient projectiles for the ghosts of Moonshine Patio Bar & Grill. When an air-conditioning maintenance man showed up to change the filters in the Carriage House bar in the summer of 2009, he was only at work for a few minutes when there was a commotion, followed by his hasty exit. "I'm never going back in there again!" he emphatically told the owner, reporting that glasses were "throwing themselves off the bar" at him.

A few years earlier, tour guide Monica ducked in out of the February chill to get a firsthand account of an experience from one of the wait staff. As Monica warmed herself in the foyer, a mist formed between the hostess area and the bar and began moving past her. It brushed the left side of her face, making it colder than the right, until it drifted down the hall toward the restrooms and the cellar stairs where it dissipated.

Moments later, one of the wait staff said that she and a co-worker had been on the back patio serving the lunch crowd earlier that week. Suddenly, a pitcher of water seated on a rubber mat at a wait station flew horizontally four feet into midair, spilling its contents everywhere as it landed. That same afternoon, the patio area experienced a common occurrence for Moonshine: mason jar glasses that suddenly break apart at an empty place setting. A guest described the incident "as though the molecules just gave up!"

One time there was only the sound of breakage without physical damage. Two patrons familiar with area ghost stories were enthusiastically discussing phenomena at another Austin location when they heard the sound of a tray being thrown against an adjacent wall five feet away. They stopped chatting, looked curiously in that direction and saw that there was nothing there. When they changed the topic to a discussion of Moonshine's ghosts, the activity settled down.

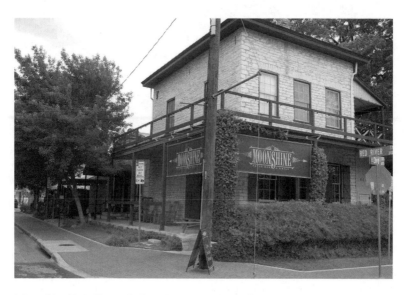

Moonshine Patio Bar & Grill at the corner of Red River and Third Street. *Courtesy of John Maverick.*

If cemetery records are accurate and there were no small children of the Hofheintz-Reissig families who died on the premises, who is the child or children having the tantrums at this popular eatery? We present this theory: Waller Creek, flowing just east of the Hofheintz-Reissig building, was once lined with homes, populated by people like Ambrosia DeLeon, Walter Carrington, Mrs. Clara Grim and, most likely, their children. Could some of the spirits in what is now Moonshine Patio Bar & Grill be those of the people who drowned? In all likelihood, yes. It is the only remaining building from that era, still a place of vibrant celebratory energy. For a wandering spirit, it would be a place of comfort. No doubt they would receive a customary welcome from the Hofheintz-Reissig household whose members knew the importance of family in good times and bad.

CHAPTER 2
RESCUE FROM THE GRAVE

The males born among Comanche tribes were raised to be warriors and raiders. When they were not plundering, they spent their time preparing for their next attack, sharpening their knives, honing their aim with bow and arrow or guns and chanting prayers to the spirits of war and good fortune as they plucked the hair from their bodies.

In the 1600s, their ancestors had come down from Wyoming through Colorado and south through the panhandles of Oklahoma and Texas to the Hill Country of central Texas. This band of wanderers, whose diet consisted of indigenous vegetation and small animals, evolved into the most fearsome of Native American tribes occupying the Southwest. By the 1830s, much of the land west of the Brazos River was Comanche territory. Everything the Comanche owned was plunder from warfare. So when a handful of new Texans, the first to push the boundaries of white occupation, built log cabins and staked their claim to land they believed unoccupied, it was a bold and brave move.

In 1833, the new homesteads of Josiah Wilbarger and Reuben Hornsby were the only two on the fringe of the frontier. Hornsby's Bend was widely regarded as one of the most enviable homesteads in the area. Others wanted their own piece of

central Texas paradise, including recent arrivals from Missouri, a Mr. Haynie and Mr. Standifer. Also Mr. Christian and Mr. Strother, who were already Austin colony settlers, were camped on the Hornsby land. This unsuspecting group ventured out with surveyor Josiah Wilbarger in August of that year and rode brazenly into Comanche territory.

Guiding their horses along the path beside Walnut Creek between east Austin and Webberville, the men rounded a bend and spotted a lone Indian about twenty-five yards in the distance; no doubt the men regarded this as a vengeful opportunity for sudden raids they had to put up with. Quickening their pace, they surprised the Comanche. As the Indian became aware of the rapidly approaching horses, he began to run, desperate in his attempt to escape. One of the riders galloped past the man and turned to face him, cutting off his only route. Gathering around the frightened Indian, the men taunted him, poking at him with their rifles and daring him to fight back. When their fun was over, they let him run up the ridge and out of sight. What the men failed to realize was that before a Comanche war or raid party embarked, a scout was sent either a half or a full day's distance ahead to spy and then report back enemy information. This Comanche scout was a mere hour away from the war party.

Soon the group of men found a place to stop for lunch and dismounted in a heavy stand of oak trees near Pecan Springs in present-day East Austin. Confronting the Comanche was unsettling to newcomers Haynie and Standifer. They kept their horses saddled while Wilbarger, Christian and Strother unsaddled their mounts and hobbled them to graze; a fatal mistake for what was to follow.

The peace of the oak grove was suddenly broken by war cries, gunfire, and arrows. Each of the men immediately tried to get behind a tree for cover. Back then a man was never separated from his gun, so the settlers quickly returned fire. Strother was the first to fall, mortally wounded. Nearby, Christian never made it to cover and collapsed when a musket ball hit his thigh,

shattering the bone. Without thought or hesitation, Wilbarger, with an arrow through his calf and a flesh wound in his side, pulled Christian behind his tree, suffering an arrow through his other leg in the process. Moments later, Christian slumped over dead.

Realizing they were outnumbered and outgunned, Haynie and Standifer made a mad dash for their saddled horses—the Indians had already captured the hobbled ones. Wilbarger looked up from reloading his gun and watched his companions mount and gallop away. He screamed desperately for them to stop and take him with them. He wanted them to slow down just enough to let him jump on the back of one of the horses. Dashing from his cover, he limped in their direction. Hearing Wilbarger scream their names, Haynie and Standifer turned their heads to see Wilbarger, arms outstretched, eyes wild with panic, pleading for them to wait. His voice broke as a rifle ball tore through the back of his neck, exiting on the left side of his chin. He fell and a wave of knife-wielding natives engulfed him just as they had the others. Haynie and Standifer turned and rode with breakneck speed back to Hornsby's Bend.

Eyes open, Wilbarger lay motionless, appearing dead, unable to move or speak due to temporary paralysis. Helplessly, he watched the Comanche dispatch their victims. After cutting the throats of the two white men to ensure their death and taking their scalps, shoes, clothing and guns, it was Wilbarger's turn. Apparently, the neck wound looked fatal enough to the tribesmen, so they did not slit his throat—but there was the matter of his scalp. It was customary for the Comanche tribe to take not one full scalp, but smaller sections each about the size of a silver dollar. Wilbarger did not feel the blade encircle his skull, but would later say when the skin was ripped from his head, it sounded like distant thunder. The Indians gathered up their rewards, leaving Wilbarger with only a sock on his right foot.

Wilbarger drifted in and out of consciousness throughout the afternoon. When he awoke, he was feverish and aching with

thirst. He felt as though his whole body was burning, but at last he could move. He crawled to Walnut Creek and lay in the shallow water for an hour. He inched his way back onto dry land and slept until the sun began to set. When he awoke again, he was consumed with thirst and hunger. Crawling along the shore, he devoured all the acorns and snails he could find. It was not until Wilbarger noticed the maggots on his wounds that he became alarmed and decided the only way to survive was to crawl the six miles back to the Hornsby Ranch. He made it about six hundred yards. Exhausted, he leaned against an old post oak and gave up, accepting his fate.

Then he looked up and was startled to see his sister, Margaret Clifton, who lived at the time in St. Louis County, Missouri. She said to him, "Brother Josiah, you are too weak to go by yourself. Remain here and friends will come to take care of you." Though Josiah begged her to stay, she drifted away and headed in the direction of the Hornsby ranch. Confused by her appearance, yet comforted by his sister's words, Wilbarger felt a renewed strength; help was on the way.

When Haynie and Standifer reached Hornsby's Bend, they ended their story with the last sight they saw: fifty Indians surrounding Wilbarger's bloodied and broken body. Back then if your friends are set upon by Comanche, those friends are as good as dead. If a responding posse could not be quickly organized to strike back, the Texans would wait a few days before returning to the scene of the attack to ensure the natives were not in the area. They would then bury the bodies where they had been slain or return the victims to their respective ranches.

That night Rueben Hornsby's wife, Sarah, had a remarkable dream: she dreamed of a naked man, wounded, scalped and sitting by a large tree. She knew it was Wilbarger and woke her husband, exclaiming that Josiah was alive. Her husband chided her and insisted she was merely upset over news of the attack. She soon went back to sleep, and this time the dream came again, even more clearly than before; Mrs. Hornsby could not

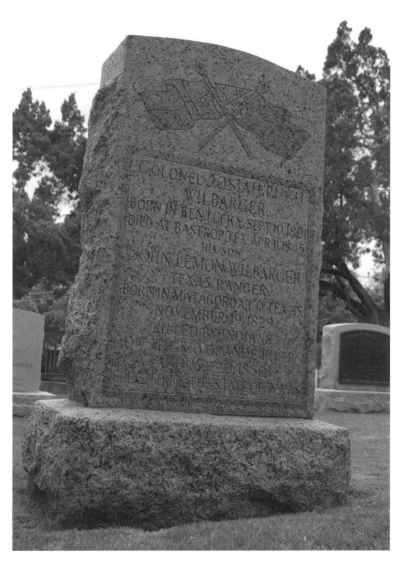

Josiah Wilbarger died in 1844 and was buried near his home. He and his wife were reinterred into the Texas State Cemetery in 1932. *Courtesy of John Maverick.*

rest. Before the sun crested the Central Texas sky, she had the men's coffee and breakfast ready and she hurried them out the door and back to the scene of the attack, making sure they had three sheets: one to wrap Josiah's naked body and the other two to cover the dead.

When the search party found Wilbarger he was not very far from the two slain men but, covered in blood as he was, one of the ranch hands nearly fired on him, mistaking him for a native. Wilbarger raised his arms, urging "don't shoot! It's me, Wilbarger!" Their first course of action was to bury their fallen comrades. Wilbarger was wrapped in the sheet and rode on horseback in front of Rueben. He stayed a few days at the Hornsby homestead before being taken to his home several miles down the river. Because the motion of a wagon would be too painful, he lay on a sled or travee for the journey.

Wilbarger's head where he had been scalped never healed, leaving a portion of bone exposed. He kept the area covered as best he could with scarves and hats, even fashioning a metal plate to cover the hole. In time though, the bone became diseased and weakened, finally exposing the brain. Sadly, infection made its way into the moist tissue and eventually worked its way to the inside of his brain. The pace of his slow deterioration accelerated when he bumped the exposed spot on a low door frame. He died eleven years after the Indian attack.

In the weeks following the ambush, the Wilbargers intended to contact his family in St. Louis County. But before they corresponded, a letter arrived from Missouri informing them that his sister Margaret had passed the day before the Indian attack. His sister's first night in her grave was the same night he lay bleeding and hopeless under that old post oak.

The story of the remarkable apparition of Wilbarger's sister and Mrs. Hornsby's dream soon spread and is still told today, making it the oldest ghost story in Central Texas history.

CHAPTER 3

OLD SOULS

The Confederate Women's Home

Battlefields, cemeteries and hospitals, as well as areas where such places once stood, are often the most haunted places of any community. Such is the case of a building along an Austin suburban street known as the Confederate Women's Home.

Texas allied with the Southern cause from 1861 to 1865, the years of the War Between the States. During the war, groups of women throughout the South gathered together to do what they could to support the Confederate cause. They continued their efforts even after the war, and by 1895 these local groups had become state organizations and combined together, calling themselves United Daughters of the Confederacy (UDC).

The federal government provided Union soldiers with a pension but not Confederate soldiers. The need for a place to house disabled and indigent veterans unable to care for themselves as they grew older became urgent, and the Texas division of the United Daughters of the Confederacy was in the forefront of the efforts to raise money to aid these men. In 1886, the construction of the Confederate Men's Home was completed on twenty-six acres of land near what is now the corner of West Lynn and West Sixth Street.

As the years went by and the need to care for the wives, widows and orphans of these men became equally urgent, the UDC made these women a top priority. The Confederate Women's Home opened its doors on the one hundredth anniversary of Jefferson Davis's birth on June 3, 1908.

The home was opened "to all wives and widows of honorably discharged Confederate soldiers who either entered the Confederate service from Texas or came to live in Texas prior to 1890." Women who could prove that they actively participated in the Confederate War effort were eligible for care in the home. All residents of the institution were required to be 60 years of age or older, without means of support, and physically unable to make a living.

In the Texas State Archives, there are a scant 27 boxes and a total of 363 files that represent women who once lived and died at the home. Since the building housed at least 3,000 women, it is evident that quite a few files have been lost over time. It was not unusual for the boxes to have been kept in private homes, but after being given to the state many were destroyed due to lack of space.

Most files had only basic information about each woman, excluding a precious few of the files that contained correspondence between the superintendent and family members, allowing a glimpse of what life was really like in the home. Standard information, however, included only her name, date of birth and death, what to do with her belongings following her death and where she desired to be buried. Some are buried next to their husbands in the Texas State Cemetery.

Many of the women who entered, lived and died at the Confederate Women's Home were childless. Some were so advanced in age that they did not know where they were. Many were brought by families that did not have the financial means for the increase in medical care. At the home, doctors and nurses were on call twenty-four-hours a day. Octogenarian studies indicate that when an older person who has spent much of their years at a

Many of the women who died at the Confederate Women's Home were buried next to their husbands at the Texas State Cemetery. *Courtesy of John Maverick.*

certain location and experiences a major change late in life, such as being admitted to an old folks' home, it hastens their demise.

Actually, the Confederate Women's Home was much like a nursing home today. Every level of contentedness and disgruntled feelings could be observed. Some lived at the home for thirty years while others were there only a few days or hours.

As Superintendent Miss Katie Daffan once wrote,

> *Some little old ladies thought the Home was heaven. Some did not like the food or the way it was cooked or the clothes they were given. Some had their husband visit* [usually these men resided at the Confederate Men's Home]. *The residents quilted and tatted, or knitted, or crocheted, or did just plain sewing. Volunteers were frequently in the Home and the ladies attended church in the front parlor. However, not all the ladies who lived there were that lively. Some were in need of constant care or were cranky and demanding.*

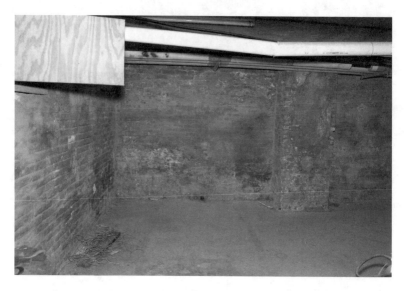

This was once the morgue beneath the Confederate Women's Home. *Courtesy of John Maverick.*

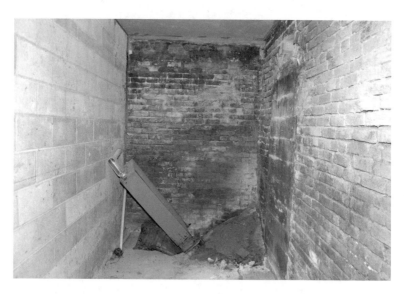

The old morgue beneath the Confederate Women's Home. *Courtesy of John Maverick.*

In 1912, the state took control of the building, and in 1916, due to the steady increase of needy women, an annex was added, increasing the number of beds available. This was followed by a full-service hospital called the Fannie Mae Memorial Hospital after the mother of J.E. Ferguson, governor of Texas at the time. The Confederate Women's Home could now house eighty to one hundred women at a time.

Still, by the early 1920s, overcrowding was a problem at the hospital and the new applicants were ill and bedridden. Another hospital and morgue were added in 1924. By the 1930s, admissions began to slow down and most of the women were either confined to a bed or in need of constant care.

The Board of Texas Hospitals and Special Schools was in charge of the Confederate Women's Home after 1949 at which time it received little attention since it was a declining institution at a time when the board was experiencing an increased need for services at other hospitals, most importantly the Texas State Hospital.

During this time, most of the women were in ill health; senility was a factor for many. The building fell into disrepair and the Fannie Mae Hospital was the only building that remained opened. In 1963, the last three remaining women were moved to private nursing homes and most of the building was abandoned until it found new purpose for a different generation.

Before the rubella or German measles vaccine was created in 1969, a rubella epidemic swept across the United States in the early '60s. Many of the pregnant women who contracted the illness miscarried, but approximately twenty thousand did not and they gave birth to children with severe deformities, including deafness, blindness, heart defects, mental retardation and other disabilities.

In 1972, the Texas State School for the Blind opened the newly renovated Confederate Women's Home as a learning facility for their students affected by the rubella epidemic. The Fanny Mae Memorial Hospital was torn down and a new brick building was constructed; the original home and annex

were converted into classrooms, a gymnasium and an area for physical therapy. What used to be rooms for the aging ladies became rooms for the children.

The multihandicapped children lived in the building learning basic life skills such as using a toilet, feeding themselves, as well as basic education and physical therapy.

Ten years later, the children were returned to the main campus at the Texas School for the Blind and the Confederate Women's Home was sold. The profit from the sale was used to build a permanent facility for their rubella students.

In 1986, the building's purpose once again centered on senior citizens, becoming home to the Austin Groups for the Elderly (AGE), a partnership of different organizations that offer services to the elderly. It is uncertain why the ghost stories began then, but they came pouring forth!

One AGE employee reported:

> I saw an old woman in a white suit with white gloves and hat, walking out of a storage closet in the Elder Haven Adult Activity center. I followed her to see where she went. The woman entered the break room where several people were seated. Just as I entered the room, the woman I was following vanished, but one lady seated in there exclaimed that she was suddenly very cold and felt like some one was watching her. I told her I had just seen a ghost walk in.

Tammy, another AGE staffer gave this account:

> I was working late one night in my office on the second floor when I heard what sounded like a bunch of women talking and laughing outside my door. I walked out several times and as soon as I opened my door the talking stopped, but once I closed the door and returned back to my desk the talking and laughing would start up again.

There is this story from AGE employee Sandy:

Late last year, we kept noticing that the Xerox machine was getting turned off early. We asked around the staff and each of them said, "No, it's not me." I thought it might be some pre-programmed time within the machine, so I asked the technician when he was out one day, and he told me that there wasn't a timer switch on that machine…The machine would be on, and then the next minute the switch would be in the off position. One afternoon I was in a hurry, and I literally turned around briefly to do some sorting when I heard a "click." Sure enough, the machine had been turned off, except there wasn't anybody else there!

There is a small two-story structure behind the main AGE building that was constructed in the 1930s. For a while a nearby school rented it for their football team.

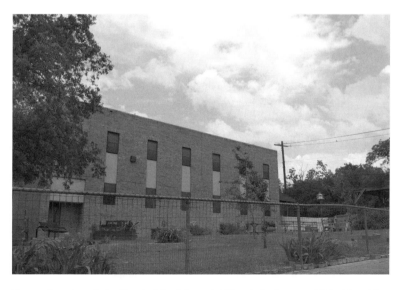

Former location of the Fannie Mae Memorial Hospital. *Courtesy of John Maverick.*

A member of the team told this story:

We would often come back to our building after a night game in order to change. There would be a dozen or so of us all hanging out upstairs making noise and watching highlights of the game on the television. Every so often, no matter how loud we were, we would hear an even louder banging as if someone was stomping up the staircase that led to the second floor. Often we would turn off the television and sit quietly as the banging continued. As soon as one of us would make the move to walk over to the stairway and look down, the banging would stop.

An AGE employee who did not wish to be identified admitted:

I was working on a Sunday. To my knowledge the rest of the building was empty. There had been some tenants in and out earlier, but I hadn't heard anyone for some time. I stepped outside to get some fresh air and take a break, and then I went back in. As usual on the weekends, the hall lights were dimmed with only every other fixture on. As I approached my office door, I stopped, startled, because I could hear a child screaming in pain or fear…mostly terror, I think. The sound was very faint, like something just out of reach, and I couldn't tell which direction it was coming from. It was almost like it was part of the air itself or in the walls. At the time I didn't know that the AGE building was once a home for disabled children. The sound faded and I never heard it again. The whole experience, though, was unnerving.

As though to strengthen the case of haunting by a child or children, AGE employee Celia told us:

I had left my office one day and was pulling away in my car when my passenger side window started to roll up and down on its own accord. It was an electric window and I had

never had any problems with it before. I kept trying to keep the window rolled up but after a few minutes it would roll back down on its own and then up, as if a child were playing with it or someone who had never seen an electric window before. This went on for several weeks, and I took the car from mechanic to mechanic, none of whom had an answer. The problem began to escalate when my door began locking and unlocking. I thought that maybe I had picked up a passenger from the building, so I turned around and went back to the office. I parked the car and told whoever might be in there that they could not come home with me and that they had to return back to AGE. I then walked back to my office hoping that I was being followed. I waited a few minutes and returned to my car. I had no further problems with the windows or door locks after that.

For a period of time there was a children's daycare in the AGE Building. Every evening the staff would pick up all the toys and put them in their proper storage area. In the morning, though, it was not uncommon to find toys scattered up and down the hallways. Were the playful spirits those of once-disabled children?

It should also be noted that while conducting an investigation of the Confederate Women's Home, my team not only recorded disembodied adult voices but also whispers and chimes.

CHAPTER 4

MYSTERIES OF MOUNT BONNELL

For generations the 780-foot bluff Mount Bonnell has perpetuated tales and legends by many of those who have encountered its cliffs, caves and panoramic view. Even today, many visitors insist that strange mists and quick-to-vanish apparitions are visible at dusk. What are they? Who are they? When did they come to know this spectacular site?

For hundreds of years this hilltop was a religious sanctum for Native Americans inhabiting the area. It was not until the Spanish traversed these parts that the reigning summit took on a different image. True to the passionate nature of their Castilian blood, the Spaniards believed that such a fine demonstration of earthly splendor could inspire only love—and not ordinary love but tragic love. It was from the era when conquistadors and explorers crossed this Central Texas region that the tale of Antonia's Leap originated. The story is so romantic that it leaped into France and our damsel in distress became known as Antoinette.

Antonia was a beautiful Spanish maiden who had traveled to Texas with the first Spanish explorers when they were establishing a mission near San Antonio. A Comanche chief caught sight of the maiden and was immediately charmed by the beautiful senorita. He and his warriors raided the Spanish settlement, captured Antonia and fled with her to their camp far north along

the Colorado River.

While her parents and friends were mourning their loss with tears, her fiancé took decisive action and rode after her. His name was Don Leal Navarro Rodriguez. Gallantly, he was able to rescue his love and escape. Their hasty retreat took them to the summit of Mount Bonnell, where the Comanche finally overtook the fleeing lovers. A fight ensued and, in the end, Don Leal was able to kill the marauding chief but, in the process, he was impaled by fifty arrows. Antonia kissed her lover's lifeless cheek, murmured a last prayer for divine forgiveness and hurled herself off the precipice.

This legend is all that remains of Spain's brief presence in this area. The tale of Antonia's Leap has changed throughout the years but the core element of the tragedy has remained: a lover must leap to death due to a broken heart. One story depicts a man taking the plunge following the death of his true love, an Indian maiden. In this version, the two lovers had been meeting on the peak of Mount Bonnell to enjoy the view and their privacy. When on one such tryst, the maiden's father secretly followed his impetuous daughter and discovered the forbidden liaison. Enraged, he murdered his daughter. The young boy had no other recourse to heal his broken heart other than leaping to his death. Another legend places an Indian maiden and an Indian warrior from opposing tribes in love and faced with the fact that they could never live in peace. The only option—you guessed it—was to ascend the limestone mountain, jump to their death and live together in eternity.

My favorite Mount Bonnell love story is one involving early Austin resident Big Foot Wallace (1816–1899). In his later years, Big Foot lived outside of Austin in a one-room cabin made of mismatched cedar posts. Some would call him a great Indian fighter; others would call him a dirty old man. Either way, at the age of seventy, Big Foot Wallace was in love with a young Austin girl who did not return his affection. Try as he might, he could not convince the girl to marry him. His amorous approaches

were further waylaid when he was felled by sickness. A popular cure in the 1880s for many illnesses was to ingest mercury, which Big Foot did. Unfortunately, one of the side effects of ingesting mercury is hair loss. When Big Foot's health returned so did his fondness for the young girl. His hair, though, did not.

Growing weary of Big Foot's constant attention and desiring to marry her own true love, the harassed girl had an idea: she'd give her unwanted admirer a reason why she would never marry him.

The next time Big Foot, the town eccentric, followed her down Pecan Street and once again asked for her hand in marriage, she coquettishly explained that she wanted to accept his proposal but he was bald—and that just wouldn't do. She could never marry a bald man. If he sported a full head of hair, things would be different.

Not to be deterred and determined to grow his hair back in order to marry, he headed to the top of Mount Bonnell with a skip in his step. He set up camp in one of the many caves along the cliffs and pulled out a jar of bear grease. He then proceeded to cover his head with bear grease every day and every night. It was believed at the time that bear grease would make hair grow. The problem with bear grease, it smelled horrible. He hid away on Mount Bonnell to spare the locals from the offending smell.

He stayed atop the hill for a month until his hair finally grew back. Whether it grew back due to the bear grease or time, it's not known. Either way, he anxiously returned to Austin with high hopes and wildflowers in hand—until he discovered that the girl of his dreams had married another during his absence. She had tricked him. It was improper in those days to pursue a married woman so Big Foot was left to mend his broken heart alone. He told a friend he didn't care. "A woman that won't wait for a man's hair to grow back isn't one I want," he confided. From then on his rifle and bowie knife were the objects of his affection, calling them Sweetlips and Butch.

One mystery for most Austinites and tourists alike is how Mount Bonnell acquired its name. Surely, the Indians and Spaniards

christened the mighty jagged ledge with a more eloquent name—and they may have. But Texas officials gave the impressive peak its lasting name in deference to George Bonnell, Texas's ambassador to the Indians and an author. More importantly, he was one of the 750 men who had gathered together as participants in the Mier Expedition, which was organized to enact retribution against Mexico for their constant trysts on Texas soil following the war for independence in 1836.

The Mier Expedition was not a high point in Texas's illustrious past. The group of men that had gathered together in San Antonio was sorely lacking experienced military men, consisting instead of predominantly young upstarts anticipating the loot that would be collected after invading small Mexican towns. George Bonnell and troop Captain Somervill were a few of the military men who attempted to maintain an element of order.

In November 1842, this assemblage of armed men on horseback set out, crossed the Rio Grande and entered an unfortified Laredo and Guerro. The towns were laid to waste, though Somervill did his best to get the rowdy Texans to exert some self-control. So angry was the captain by the unrestrained plunder of the town that he called off the mission and headed back to Texas. A group of about three hundred refused to follow and instead went on to attack and plunder the town of Mier. Big Foot Wallace and George Bonnell were two of these men. Unlike Laredo, word had gotten out that Texans were attacking small border towns. A large Mexican army was waiting to defend the small adobe town of Mier. The battle that ensued was actually favorable for the Texans but confusion erupted when their newly elected leader, Colonel Fisher, was wounded. During a lull in the battle, a Mexican general sent a white flag to the now exhausted and hungry Texas troop, informing them that a large army of fresh combatants would soon arrive as reinforcements. They gave the offenders the opportunity to surrender. A vote was instigated and the Texans decided to accept the offer. They were assuming that they would be held as prisoners of war somewhere near the

border and, therefore, an easy enough location to be rescued.

That was not what the Mexican army had in mind; it was a set up. In truth, there were no reinforcements on the horizon and the captured men were disarmed and made to walk south into Mexico's interior to a prison near Salado. Many of the men died during the tortuous walk through the desert. Just outside of Salado, the Texans rallied and made a successful escape attempt. Unfortunately, they had already been pushed to their physical limits and found themselves in frail condition wandering the rough terrain with no food, water or weapons. The Mexican army soon recaptured all surviving 176 men, including George Bonnell, who died attempting to help his wounded comrades. President Santa Anna ordered 159 white beans placed in a pitcher with 17 black beans. Those who picked a black bean were shot in the back. Incidentally, Big Foot Wallace did not choose a black bean and therefore was released with the others two years later.

Buried somewhere in Mexico, George Bonnell was nonetheless remembered and the magnificent land formation along the Colorado River was named in his memory.

Are the mists and moving shapes seen there the lovers, the warriors, the namesake or someone else? The mystery of the mountain we know as Bonnell remains.

CHAPTER 5

GHOST WAGON OF WESTLAKE

It was hot. Even the splotches of shade scattered along the long empty dirt road provided little relief from the relentless sun. The trickling of Eanes Creek came and went as the lone man in a wagon urged his two horses back to his ranch in the late afternoon. Hypnotized by the rhythm of hooves, he pondered the events of the day.

He had risen before dawn, eaten a quick breakfast and headed out to the barn. Making sure his load of hay was secure since the night before, he hitched the horses to the wagon. Snapping the reins, he began his journey east toward Austin before daybreak.

The road meandered around the hills west of town, and the setting moon cast long shadows over the familiar route. It had been slow going as he hauled his heavy hay wagon toward the Lower Colorado River, but eight miles later he reached the west shore and, by the first glimmer of light in the east, found the low water crossing point. On the opposite side he could barely make out where Shoal Creek emptied into the Colorado. That June morning the river ran quietly. There had been no rain since before the May Day celebration and it didn't look like there would be any coming soon. This was where he would ford the river.

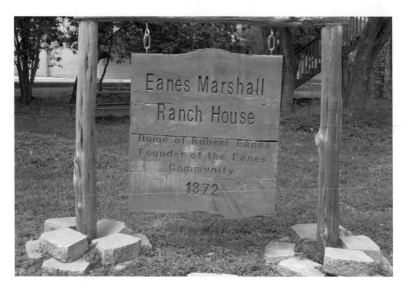

Eanes Marshall Ranch House. *Courtesy of John Maverick.*

As the sun crested the horizon, the man's horses and wagon were lumbering up the Congress Avenue to Daniel Creary's Livery Stable on Fifth Street. Creary checked the quality of the hay and, after some haggling and shaking of hands, the man was paid for his load.

A few blocks north, he reloaded his wagon with the much needed dry goods at Beryman's Grocery and Provisions. There was time enough now to sit down and have a hot meal at Kluge's restaurant, also on Congress Avenue. By midafternoon his business in town was completed and he determined that it was time to begin his journey back to his homestead among the hills west of the city.

He was moving at a steady pace when he halted the wagon abruptly. A large rock, out of place and certainly absent that morning, blocked the narrow path bordered on one side by the creek and the sloping bank of a steep hill on the other. The rock was too big to straddle and the road was too narrow to go around it.

The man took a careful look around and stared down at the obstacle. Something didn't seem right. Reaching around to the back of the wagon, he pulled out his shotgun. Cautiously listening, he carefully descended from the wagon seat and approached the misplaced piece of limestone. Looking around one more time, he crouched down, lowered his shoulder into the rock and shoved it out of the way.

Every instinct signaled for him to get out of there as fast as possible. But before he could lift his foot to climb back into the wagon, he heard the crack of a stick and the sound of rustling leaves. The hair on the back of his neck stood up and he felt a chill down his spine. He swung around, gun raised. But before he could pull the trigger, he was lying on the ground with a bullet hole through his chest and life ebbing away.

The sound of gunfire so close spooked the horses and they clamored down the cleared road running wildly before the bandits had the chance to grab the reins. No matter. As the sound of the loose wagon and horses faded into the distance, the thieves turned their attention to collecting their victim's money. They rifled through the dead man's pockets—taking everything of value—and fled even before the flies could set on the body.

Just up the hill, the Eanes family heard the gunshot crack. There was no reason for a shot to be fired so close to their house. Could somebody be hunting on their land? Indians in the area had long since vanished. The thought of foul play crossed everyone's mind as the family grabbed their weapons and hurried to where the shot had sounded. It didn't take them long to find the murdered man. His body, lying in the middle of the road, was still warm and in the heat had already begun to bloat. There was little mystery to what had happened considering what they found: the gun still in his hand, the large rock by the side of the road, the wagon tracks that led away from the bloody scene. Clearly, this stranger had been ambushed by bandits and had gotten the short end of that deal. Only one question remained: who was this man? The hills west of Austin were pocketed with

families and loners scratching out a living, emerging every few weeks to barter for supplies in town and disappearing again among the limestone cliffs.

When one of the Eanes boys returned from fetching shovels, a hole was dug and the nameless man was laid to rest in an unmarked grave. After calling on the Lord to accept his poor soul, the family headed back home.

As time passed, the location of the grave was forgotten and the story of the murder on the property was mentioned only rarely. The land, largely unoccupied, was quiet—or so it was assumed.

In 1991, when the Westlake police were searching for evidence of deer poachers, they came upon an indented patch of soil. It appeared to be a sunken grave, so the area was excavated and a body was uncovered. Bone analysis proved the skeleton to be that of a man that had died some one hundred years before. Speculation as to his identity and the circumstances of his death began.

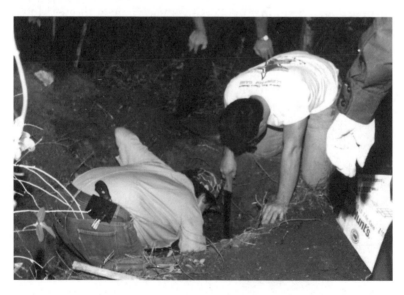

Westlake residents and police unearthing the bones. *Courtesy of Bruce Marshall.*

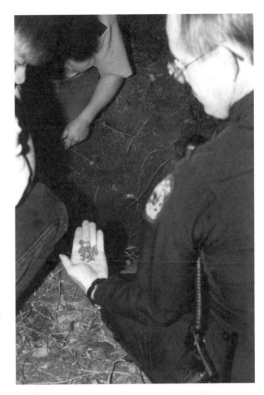

Right: Bones found. *Courtesy of Bruce Marshall.*

Below: Excavating the grave. *Courtesy of Bruce Marshall.*

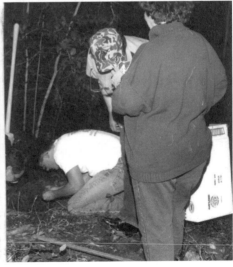

Bruce Marshall, an heir to the land, began to recall an old story he had heard as a child about a murdered traveler. Marshall was also reminded of an experience he had in 1966 when a group of five parapsychologists from San Antonio traveled to the old ranch house on a ghost hunt. The group attempted to make contact through automatic writing, a process by which the lingering spirit communicates to mortals through a psychic who is in a trance. Pencil in hand and guided by an assistant, the contacted spirit responds to questions through the psychic who then channels the messages by writing them down.

During the long and arduous night of the investigation, numerous ghosts made contact. One of the most communicative spirits was that of a man who called himself what they interpreted as Burns. He claimed that three men had murdered him after he had gotten down from his wagon to move a stone from the road. It seemed that after one hundred years, the wagon driver wanted his story told.

A newspaper reporter who witnessed the séance diligently investigated old microfilm newspaper articles in the Austin History Center and successfully found a newspaper account matching the incident. The report stated that, in fact, a man by the name of Barnes had been robbed and murdered on his way back from selling hay in Austin in 1871. The only difference between that story and the one told at the séance was the location. The newspaper stated that the crime had taken place seven miles north of the city, and the Marshall house is situated seven miles southwest of Austin.

Could his name have been Barnes or Burns? Is the man still lingering, angered by the injustice that befell him? Did his horses gallop to a frenzied death near Bee Cave Road and Loop 360?

Undaunted by the parapsychologists' experience, the Marshall family returned to the land that was their namesake, built a new home and restored the old one. They were surprised when reports of another sort of haunting began to surface soon after they had settled into their new home. What they heard was

the creaking of straining wood and leather and the pounding of hooves. The pitch of the approaching wagon would grow louder and then slowly recede, leaving only night sounds in its ghostly wake.

Apparently the ghost wagon had been heard running near the property for a long time, luring Austin youth for years late at night to the abandoned land. One summer night the family's teenage son and some of his friends decided to spend the night by Eanes Creek hoping to hear the wagon. With sleeping bags, flashlights and much excitement, the boys set up camp. Late in the night, suddenly all sounds ceased. The crickets quieted, the dogs stopped barking and the frogs were silent. From the depths of the darkness came the sound of clattering wood, the creak of metal and leather and the thunder of running horses. The boys strained their eyes to their surroundings to identify the source of the sound but could not. The beating hooves moved closer, growing ever louder. Before the pounding reached the small

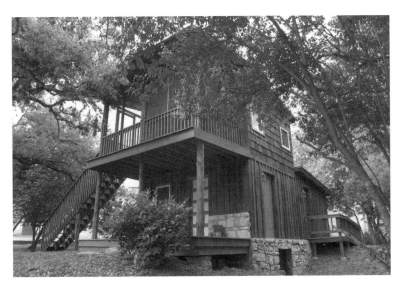

The original Eanes Marshall Ranch House. *Courtesy of John Maverick.*

group by the creek, the terrified boys ran full speed back to the light and safety of the house.

In addition to members of the Marshall family, several night watchmen at the neighboring office building resigned because of the strange ghostly sounds they heard in the night. Most notable was the sound of an approaching wagon that never arrived.

One day a man named Joel Quintanella, who had been working as a security guard at the state Capitol, ran into Bruce Marshall and described a night he would never forget. As a youngster, Joel and some friends had ventured out late one night to listen for the ghost wagon. They were laying low along the old ranch road, watching the moon filter through the trees, when at approximately midnight the sound of a wagon could be heard approaching.

"What happened?" asked Marshall, hoping he would at last talk to someone who had *seen* the ghost wagon. Joel smiled. Before the wagon could reach them, he confessed, he and his friends were halfway home.

CHAPTER 6

BLOOD, FIRE AND GRANITE

The Texas Capitol

Before our illustrious red granite Capitol stood at the crest of Congress Avenue, the Old Stone Capitol housed Texas's state business for twenty-eight years. The building went up in flames on the rainy afternoon of November 9, 1881. Its demise was quick and final. A hole had been cut into the stone between two rooms in the basement for a stove pipe. It was believed that a flue had been installed, but it hadn't. The pipe was attached to the stove in the east part of the attorney general's apartment. The other end of the stove pipe led into a storage room for papers and books. After the stove was lit, it took only two hours for the fire to turn the Old Stone Capitol building into a blackened shell. Contributing to its complete destruction was an inadequate water supply.

Construction began on the new Texas Capitol in February 1882. Texas officials had big dreams for a new Capitol, but little money to make those dreams a reality. So they traded three million acres of land in the Texas panhandle to Taylor, Babcock and Company of Chicago. As for the workforce, the contractor decided to take advantage of the Convict Lease Program the state had created.

After the Civil War, lawlessness and discord abounded in the Southern states, including Texas. The number of people

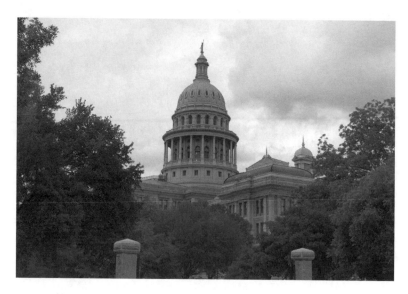

The Capitol of Texas. *Courtesy of John Maverick.*

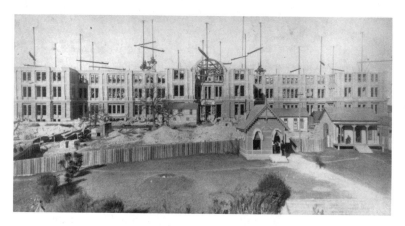

Construction of the Capitol. *Courtesy of the Austin History Center.*

incarcerated was staggering, and the state did not have the money or space to properly house the inmates. Officials decided to lease the convicts to private companies in exchange for a small fee and room and board. The contractors were interested in

making a profit off their investment, so the convicts often worked long hours with substandard food and shelter. The agreement between the state penitentiary and the Capitol contractors, known as the Capitol Syndicate, stated that they would lease up to one thousand convicts, pay the state sixty-five cents per convict per day and take responsibility for their food and clothing. The state did not regulate the process and many were ill-treated. Half of the prisoners were African American, even though only 25 percent of the state population was black. For the previously unskilled convict laborers, breaking tons of rock was—needless to say—dangerous work. As prisoners, these men were not held in high regard and their lives were of little value. Consequently, loss of life under these extreme circumstances was unrecognized. Nonetheless, the labor the prisoners provided was paramount to the creation of the Texas Capitol.

Convict labor was used from the very beginning of the Capitol construction when subcontractor Gus Wilke blasted and carved out the basement from solid stone. For the next six years, he would oversee all aspects of construction. In Oatmanville, known today as Oak Hill, Wilke leased a thousand acres of the limestone quarry so one hundred able-bodied convicts from the Huntsville prison could send ten railroad cars full of limestone to Austin each day. This limestone was used for the interior walls of the Capitol. At Granite Mountain in Burnet County, the red granite was donated and was quarried by prisoners who cut, shaped and loaded a total of fifteen thousand rail cars to Austin for the outer walls of the building. The convicts slept in a wood frame structure on the southeastern quadrant of the Capitol grounds. Each day they worked under the watchful eye of several guards and their dogs. In addition to the work done by these convicts, the ironwork used to make the dome, columns, gates and interior decorative work was fashioned by prisoners at the foundry at Rusk State Prison.

Tales of mists, ethereal images and unexplained lights on the Capitol grounds have been reported for years from Department

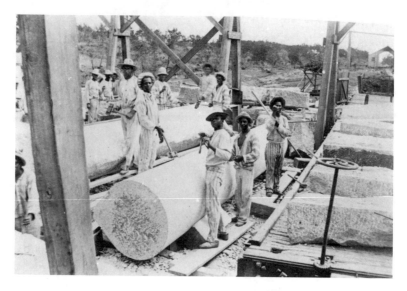

Convict labor working on limestone pillars for the Capitol. *Courtesy of the Austin History Center.*

of Public Safety officers, employees and visitors. In all likelihood, at least a few reports of roving lights and orbs in the trees can be attributed to the nameless, forgotten convicts who gave their labor and their lives in the shadow of the Capitol.

During those six years of construction, thousands of people contributed to the new Capitol. Everyone was working toward a common goal: to build the largest Capitol building in the United States, even bigger than the nation's Capitol in Washington D.C. And they succeeded.

Since the completion of the original building in 1888, many changes have taken place, including a restoration and expansion following the fire in 1983 that began in the lieutenant governor's living quarters. During that fire, 102 years after the fire that destroyed the Old Stone Capitol, a man died when he was overcome by smoke. Instead of running out of his bedroom door to safety, he wasted precious minutes and energy struggling unsuccessfully to open a window that was nailed shut.

Does this young man's spirit still linger behind the walls of Texas's Capitol? If so, he is not alone.

It was an assassination in 1903 that has resulted in the most identifiable ghost centered around a man who was such a dedicated public servant, he still walks the Capitol halls.

At ten o'clock in the morning on June 30, 1903, the state comptroller, Colonel R.M. Love, was sitting at his desk in the east wing of the Capitol talking with Rev. Cowden when in walked Mr. W.G. Hill. Mr. Hill was an unemployed former state employee. Later it would become apparent that Love was responsible for Mr. Hill losing his job. Unaware of the intruder's intentions, the two men greeted Mr. Hill and continued their conversation until Rev. Cowden bade his farewell, leaving the remaining two men alone. As he left, the reverend saw Mr. Hill hand Love a piece of paper that read:

> *Dear Sir—Public Office is a public trust. Public offices are created for the service of the people and not for the*

The comptroller's office in the Capitol. *Courtesy of John Maverick.*

aggrandizement of a few individuals. The practice of bartering department clerkships for private gain is a disgrace to the public service and in the nefarious traffic you are a "record breaker."

You have robbed the state's employees, and your incompetent administration has permitted others to rob the state. The man who, claiming to be a Christian, deprives others of employment without cause is a base hypocrite and a tyrant.

The greatest mind that ever gave its wisdom to the world; the mind of all others most capable of "umpiring the mutiny between right and wrong," said: "You take my life when you do take from me the means by which I live."

If that be true, you are a murderer of the deepest crimson hue.

Although I cannot help myself, before laying life's burden down, I shall strike a blow—feeble though it be—for the good of my deserving fellowman.

"For the right against the wrong
For the weak against the strong."
Yours truly, W.G. Hill

While Love read the letter, Hill took a .38-caliber Smith & Wesson from the pocket of his jacket and shot the comptroller in the chest. Mr. Stephens, a bookkeeper in the adjoining office, quickly left his desk and entered the room to witness Hill fire a second shot. Stephens rushed toward Hill just as the gun was turned on him. Moving quickly, Stephens ducked beneath the line of fire, grabbed Hill around the waist with one arm and caught the pistol with the other hand. A struggle ensued. Hill broke loose and headed for the door; Stephens caught him, and the grappling men fell backward onto the floor, each fighting for control of the gun when a third shot sounded. By this time, the Reverend Cowden had re-entered the room with Miss Annie Stanfield, the comptroller's personal stenographer on his heels. Both watched in horrific suspense as the two men stopped battling and lay still on the floor. Finally, Stephens disengaged himself slowly and rose

to his feet as a pool of blood collected beneath Hill; he had been shot in the chest. Mr. Hill reached into his jacket pocket again, this time to remove a vile of laudanum, a popular opiate. "Let me take this and die easy," he pleaded, but as he raised the liquid to his lips, Stephens slapped it out of his hand—there would be no quick death for this assassin, but a slow, painful one.

Colonel Love struggled to his feet and attempted to walk, only to fall back to the floor, stating the obvious: "I've been shot." Everyone in the Capitol rushed into the east wing. Love was placed on the couch in his office with a pillow beneath his head. Hill was placed on a cot just inside the doors on the south side of the rotunda. One hour and five minutes later, Love's wife, son, sisters and the governor were at his side when he took his last breath. Remarkably, R.M. Love's final words were of compassion and forgiveness toward the man who shot him. The *Austin Statesman* reporter on site stated, "With the vital blood percolating from his body in two places, converting snowy drapery into crimson folds, tossing his head from side to side, eyes closed and fingers clenched, the victim of the assassin's bullet blessed his precious wife and children, and in the spirit of the Savior he had tried to serve, prayed 'Ah, God forgive and save him who hath robbed me of my life.'"

Mr. Hill, meanwhile, was transported to the Austin Sanitarium, where he died at 2:55 p.m. that afternoon.

The *Austin Statesman* reported on July 1, 1903:

> *Texas loses her first official at the hands of an assassin. Two united and loving families are deprived of their heads. Two homes are filled with sorrowing relatives. Two souls stand before their maker at the judgment bar. The sadness is added to by the fact that both men were of exemplary habits— honorable, Christian gentlemen—respected and loved by nearly everybody in this community. The friends of one were in many instances the friends of both. Dr. John E. Hill of Manor, one of the most prominent men in Travis County, was the brother*

East wing of the Texas Capitol. *Courtesy of John Maverick.*

Rotunda of the Capitol. *Courtesy of John Maverick.*

of the killer and a close friend of the killed. They were both of the oldest and best known families in the state, and both leave behind them desolate wives and weeping children.

Not long after the shooting, the figure of a man walking through the east wing could be seen, only to fade away. Still spotted today, he is described as wearing period clothing and wandering the east hallway on the first floor. Reports abound of an oddly dressed man, nodding to passersby and wishing them "Good day." Those who give the archaic greeting a second thought may turn back to get another look, only to find that the man has disappeared.

A guest on an Austin Ghost Tour who was interning as a page at the Capitol during a special session of the legislature was on the phone to her mother, reporting that the vote was lengthy and she would be home later than she thought. As she turned off a long hallway, a man passed by, smiled and said "Good evening." The young lady nodded back as he rounded the corner. She told

South side of the Capitol rotunda where Mr. Hill was left to die. *Courtesy of John Maverick.*

her mom, "I'll call you back. Someone just said hello to me. I'm not certain who he is, but he might be important and I don't want to be rude." She closed her phone immediately, but as she turned the corner to that long hallway, there was no one there. When shown a photograph of the colonel, she was astonished. "That's him," she exclaimed, "I recognize the bushy mustache!"

In addition to being spotted by witnesses, Colonel Love has also been seen on security footage. Every now and then, the cameras will follow a crowd as it moves down a hallway when someone oddly dressed will jump into frame. Conversely, there are other times someone who was among a group will disappear from the camera's view the very next second.

Does the colonel's soul linger, still an over-zealous public servant? Are the convicts, now without the weight of their physical bodies, released at last, allowing their bright gentle souls to wander? Visitors, security guards and state employees attest that these and other spirits roam the hallways and grounds of a state capitol imprinted with blood, fire and granite.

CHAPTER 7
SWEN BERYMAN

Pioneer times were an era in America's past when individuals and families left what was familiar and ventured forth into barely tamed lands in anticipation of a better life. These enterprising people arrived from settled areas in the United States and scattered countries with a large percentage migrating from European soil.

Swen Bergman left his home in Ekjo, Sweden, alone in 1852 at age sixteen. Months later he disembarked at Galveston harbor and wandered onto a new continent swarming with people with big dreams and high hopes, just like his. Swen took in his new surroundings. Though the Galveston harbor was an active port with sailing ships from all over the world, the scene that slowly unfolded as the ship drew close to the dock was nothing like what Swen had anticipated. How could he have known what to expect? Texas was still a wild state compared to the port of Amsterdam where he had embarked on his trip across the Atlantic and then south to the Gulf of Mexico. Swen's true name, Bergman, would be lost forever once he arrived in Texas. Immigration officials misspelled his ancestral name and documented Swen's name on his citizenship papers as Beryman.

Now, as a new Texan filled with perseverance, energy and faith, Swen worked as much as he could, doing whatever he could to earn a dollar. He took to the saddle as a cow puncher, labored as a farm hand, became a blacksmith's apprentice and even drove a freight wagon to and from small towns along state highways that were little more than wagon ruts between sagebrush. During this time he saved his hard-earned wages, and when he had accumulated enough money he purchased cattle, horses and land.

Following ten years of hard work, at the age of twenty-six, Swen began correspondence with a Swedish girl in New York City. Although Johanna Anderson's job as a housemaid took much of her time, she always found a way to write long and thoughtful letters to Swen in far-away Texas.

The Civil War erupted. In spite of the hostile and desperate condition of the country, Johanna was able to travel by stagecoach from Union territory onto Southern soil in 1863. The couple married and settled forty miles west of Austin outside of Johnson City on a small parcel of land Swen had purchased.

Like many new European immigrants, Swen and Johanna favored the Union. Living in a Southern state, their staunch support of Yankees made peaceful coexistence among their neighbors difficult. Nonetheless, they made it through the war and Reconstruction era, and their little farm thrived until the winter of 1878 when tragedy struck.

One brisk mid-November day, Swen Beryman and three comrades were riding along the base of the awesome Devil's Backbone, headed in the direction of the eerie double peaks known then as Long Man Mountain and Long Woman Mountain, which rise fourteen hundred feet above the Texas plain. At that time, evidence of ancient Indian shrines was still visible on the zenith of each mountain.

The remains of Native Americans who inhabited the land long before the Texans were plentiful throughout the Hill Country. There was much superstition and some fear among the settlers who found themselves in the area of these sacred Indian sites and

shrines littered throughout the countryside. No area in the Hill Country generated as much superstition, though, as the row of rolling hills known today as Devil's Backbone. This spiritual core of Native American worship is where Swen and his companions found themselves that fateful day.

As late afternoon approached, the group experienced an uncommon natural phenomenon. The sky turned black and the temperature began to drop rapidly just as the trail leading up to the top of Long Woman Mountain came into sight. Lightning flashed and hail pelted them as a storm settled above the small group of men. At the base of the impressive incline the horses began to spook and all but Swen became frightened. The men were already in a state of anxiety, unnerved by the unexplainable events told by those who dared to traverse the once sacred hill. As they insisted on turning back, Swen laughed at their irrational fear and continued on. Ascending the sloping trail alone, thunder began to crash, the wind bit into his skin and the temperature continued to plummet. Swen was forced to dismount and find shelter among the rocks and thicket, huddling there all night.

Concerned because Swen had not returned to their campsite as the sun crested the horizon the next morning, his friends found the courage to climb the hill and look for him. They found him tucked in his meager shelter, but not soon enough. The temperature on the hill had dropped so low that frostbite had set in and Swen's lower appendages were frozen. By the time they had transported him to the local doctor, it was too late. The doctor had no choice but to saw off the damaged legs to prevent gangrene from claiming Swen's life.

Swen survived the double amputation at a time when many men did not, and later he worked on two artificial wooden legs. Although his wooden legs allowed him to walk, he could not keep up with the responsibilities a ranch required. He sold the ranch and moved his wife and children to Oatmanville where he purchased a general store; a store that still stands today as the Austin Pizza Garden.

Swen Beryman managed the store and the local folks he dealt with unanimously agreed that he was a fair man. He was also ready and willing to protect his property at any cost. He demonstrated that resolve in 1880 when confronting a desperado.

Brack Hendericks made a stop at Swen's to pick up the tobacco he would need while hiding out in the hills west of the city. On the run and in an aggravated mood, Hendricks barged into the little store as Swen was scrubbing the counters, and he took the liberty of helping himself to the smoke and chew in the glass display case. Brack didn't believe the immigrant with no legs was any match for him. As the outlaw hastily grabbed tobacco and stuffed as much as he could into his pockets, the outraged Swen demanded that he stop.

Ignoring Swen, Hendricks looked around the mercantile to see if there was anything else he might need while on the lam. Before Brack knew what was happening, a quick-thinking Swen threw a can of scouring powder into the thief's eyes. Swen then proceeded to hop onto the counter, reach over and pull Brack's gun from its holster. After taking out the bullets, he turned the gun around and hit Hendricks in the forehead. Stunned and blinded from the powder, Brack began choking on the chew he had stuffed in his mouth and fell unconscious onto the floor just as a Texas ranger and sheriff's deputy came through the door. They had seen the brand on the horse tied to the hitching post in front of the store and recognized it as the one stolen by the man they were tracking. They thanked Swen for slowing the criminal down and offered him the reward money for his capture. Swen refused the reward money. He did, though, take his tobacco back.

Swen's general store still sees a brisk business today as the Austin Pizza Garden. The old stone structure stands out amid the more modern shopping plazas, and accompanying the steady flow of customers there are the consistent reports of odd occurrences.

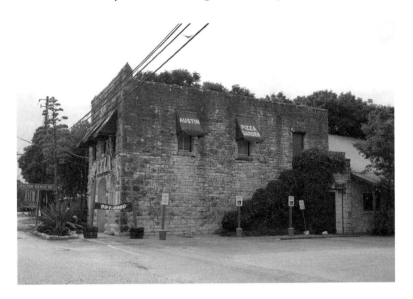

The Old Rock Store today. *Courtesy of John Maverick.*

There was the time when the owner was the last to leave Austin Pizza Garden for the night. He had prepared a pizza to take home to his family beforehand. Just before locking up the restaurant, he took the pizza out of the oven and sliced it. Stepping away for a few moments to retrieve a box, he was astonished to find upon returning that the pizza was once again whole and uncut, crust, toppings and all—even though the roller with remnants of steaming toppings was still in his hand.

Occupants of the party room upstairs often hear the sound of footsteps walking past even when everyone is seated. Sometimes when the restaurant is quiet, near or past closing time, the footfalls can be heard from downstairs, although the staff knows the party room to be empty.

An old woman was often seen on the second story, particularly near the stairwell. She would scowl at staff members as though they were intruding, and then disappear. Interestingly, an elderly woman who had lived in the building, before it became Austin Pizza Garden at 6266 West Highway 290 in Oak Hill, once

Entrance into the haunted second-floor front room. *Courtesy of John Maverick.*

Haunted back staircase. *Courtesy of John Maverick.*

stopped by and asked to look around her old residence. When she led staffers upstairs to the front room on the second floor, she reported, "Oh, and here is where I used to see that mean old ghost woman!"

It is believed that one of the spirits lingering in the Old Stone Storehouse is that of the indomitable Swen Beryman.

CHAPTER 8
THE DRISKILL

The various groups of tribes or nations of Native Americans in North America may have had different languages and social customs, worshiped different gods and eaten different foods, but a common trait was their spirituality. The earth was sacred. They were part of the earth and the earth was part of them. Each worshiped his or her own private spirits in addition to the collective spirits of the tribe. All that was mysterious about life, death and the afterlife could be explained through the intercession of the Great Spirit and the ancestors that had passed as well as nature and animal spirits. Good and bad spirits, messages and omens were contained in all aspects of nature. The tribe's medicine men and shamans, the ones closest to the spirit world, interpreted the signs and symbols. Communication with the unseen was part of daily life and these forces dictated outcomes for the hunt, the battle, birth and burials.

The nomadic Native Americans who traversed the area around Central Texas and specifically the Austin area were the Comanche, Apache, Tonkawas and Kiowas.

Comanche spiritualism was centered on males, just as it was in daily life. Just before puberty a boy would go on a quest to find his own personal spirit guide. Through the spirit's guidance,

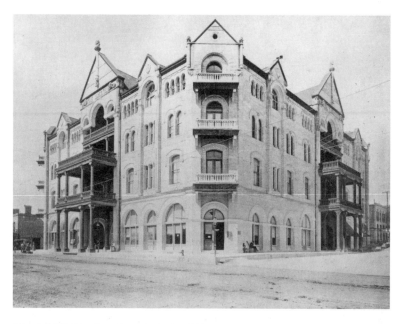

The Driskill Hotel; to the right is the old laundry and kitchen building. *Courtesy of the Austin History Center.*

the boy would be given information about how to best live his life. These were good spirits that could turn evil if they were not respected and honored. Comanche were not afraid of ghosts and they, like all central Texas Indians, believed in life after death. They also believed all spirits could reside in any object and certainly in natural objects such as springs, high places and unusual land formations.

The Apache, unlike the Comanche, greatly feared ghosts of the dead. When death occurred, that location was avoided and the body was quickly buried. When the burial was complete, the family would leave the grave using a different path than the one that brought them there, hopefully outwitting the deceased from following them. To further confuse any lingering spirit, they also moved the teepee to a different location.

Like the two previous tribes, speaking the name of the deceased was forbidden for the Tonkawas, as it could call forth

the wandering spirit. Their afterlife was kinder to women, whose souls went directly to a new home in the west, while male souls hung around the living, trying to communicate and taking care of unfinished business. The Tonkawas also believed that if a soul haunted a place where people lived, the inhabitants would soon die.

The Kiowas, like the Comanche, sent their boys on the eve of puberty on a vision quest. In the seclusion of the woods they would fast and pray for a spirit to guide them through life. Real or imagined, these spirit guides strengthened the resolve for the tribes who made war against the white man or each other.

All held deep spiritual beliefs associated with the gift of water and the sacred sites where the earth brought forth water, especially in the arid lands of Central Texas. They all also collectively believed that these waters held spirits, willing and unwilling. They all stopped at the artesian well in Central Texas that would later become the corner of Sixth Street and Brazos in Austin. The well was the main reason Colonel Driskill wanted his hotel to be built

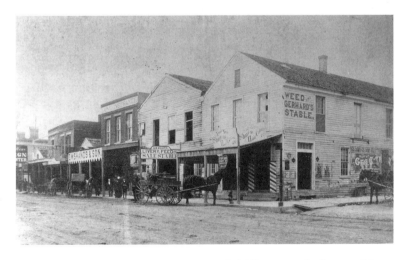

Corner of Brazos and Sixth Street where the Driskill now stands. *Courtesy of the Austin History Center.*

on that corner, where the city bathhouse once stood. The well supplied water for the hotel for many years.

Supporting urban renewal, Colonel Driskill had plans to transform the Sixth Street corridor from a rough and shabby area of Austin into a respectful extension of Congress Avenue. The current Capitol was under construction at this time as were six limestone buildings along Pecan Street. The University of Texas had two successful years of instruction under its belt and the student population was increasing. Clearly the city was destined for greatness, therefore it would need a hotel that held the highest standards of the time. The Driskill Hotel would set the precedent for what Austin should aspire to become; a city of grandeur to suit its status as the capital of the great state of Texas.

Colonel Driskill was an entrepreneur who made his money after the Civil War by rounding up the huge numbers of wild Texas longhorns and herding them north to the railroads in Kansas where they were dispersed. Before the war, nobody much liked the Texas longhorns; they were skinny and ill-tempered. But after the war—to a starving nation—they were looking pretty good.

With Colonel Driskill's unstoppable resolve to build the finest hotel west of the Mississippi and fueled by his vast fortune, the cornerstone for Driskill was laid on July 4, 1885.

The Driskill was for many years at the apex of Austin's social scene. Inaugural balls, graduations, weddings and parties have all been celebrated in its ornate rooms. During Prohibition years, the Driskill supported the finest speakeasy Austin had to offer.

The entrance from Sixth Street was for the genteel patrons. This entrance allowed one to walk through a hallway directly to the elevator, which would ascend to the respectable Mezzanine level. This second floor had a grand dining room, a club dining room, ladies dressing room, two large parlors, two bridal apartments and a few guest apartments. The two remaining floors were guest rooms. The first floor entertained cattlemen, gamblers and other gents with the billiard room, barber shop, saloon, drugstore and bank. The boiler room, kitchen and servants quarters were in a

An event in the Maximilian room. *Courtesy of the Austin History Center.*

detached three-story structure next to the hotel on the north side where today stands the new addition built in 1927. The hotel had steam heat and hydraulic elevators. On the original side, the ceilings are twenty feet high and every wall partitioning the rooms is constructed with twelve-inch-thick brick. This was, of course, to contain fire—a constant threat in those days.

Six months after it opened, the Driskill closed. A long drought (or the Great Dry-Up, as it was known) followed by 1885's bitter cold winter (the Great *Die*-Up) put Mr. Driskill and many other cattle barons out of business. The hotel has been bought, sold and foreclosed at least fifteen times during its long history. It finally became a historical site in 1966, preventing the hotel from being replaced by a parking garage.

One evening a number of years ago, I was sitting at the Doubletree Hotel in Austin and struck up a conversation with a

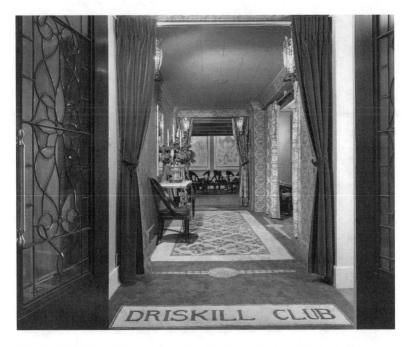

The Driskill Club, which is now the Citadel Room. *Courtesy of the Austin History Center.*

couple sitting at the bar. When one of these individuals learned that I gave the Ghosts of Austin Tour, she became very excited and told me this story.

The woman and her girlfriend were in Austin in 1999 for a conference and were staying at the Driskill. Having heard prior to their stay that the Driskill was haunted, they requested a room on the famed fourth or fifth floors. The clerk informed them that those floors were undergoing extensive renovations and were therefore closed to guests.

On the final night of their three-day stay in Austin, the women returned to the Driskill. On the way back to their room, they decided to see if they could get to the fourth floor and take a promenade, just for the thrill of it. The elevator stopped and they exited onto the fourth floor on the new side of the hotel, turned right and went through the double doors connecting

the old side of the Driskill. When they reached the bottom of a small staircase, the telltale ladders, materials and plastic sheeting from the renovations littered the hallway. There wasn't much to see except a woman walking down the hallway away from them—she was carrying many shopping bags. The first thought that entered the ladies' minds was: "Where was she shopping at 2:00 in the morning?" Their second thought was that they were denied access to this floor due to the obvious renovations! So why was someone *else* able to stay on this floor?

The women watched as the lady turned and faced a room at the end of the hallway. One of the women called to the shopper, "Excuse me, doesn't it bother you to stay on this floor while the renovations are going on?" Without turning, still facing the door, the woman clearly said, "No. It doesn't bother me at all."

With the woman's response also came an odd sensation; a feeling of imposition, and the urge to leave as quickly as possible.

The next morning, while checking out, they asked the front desk clerk why they had been told they could not stay on the fourth floor while someone else was told that they could.

The clerk responded, "You're mistaken. No one is staying on that floor."

"Yes, someone is, because we saw them."

"No, there are no guests on that floor."

"Yes, there is!"

The clerk checked the registry. "No, there is not. I'll prove it."

Together the two hotel guests and the front desk clerk went to the fourth floor. They found lots of activity, busy construction workers and the doors to the rooms propped open. As they approached the threshold where the lady had stood, a sinking feeling began in the guests' stomachs. The mattress was still covered in plastic and leaning against the wall. The new commode had not been installed and was parked where the bed should have been. Clearly no one was staying in that room.

They didn't know what I and just a few other Driskill staff members knew at the time: In the early 1980s, a Houston

socialite's fiancé canceled their wedding. She called the Driskill and reserved a room for five days. Soon after checking in, she went to the bar and ordered a diet soda. She then left the hotel and went on a shopping spree, spending $40,000 on her ex-fiancé's credit cards. She returned to the Driskill with as many shopping bags as she could carry and the rest of her purchased items were delivered to the hotel; she then closed the door to her room and locked it.

This woman's arrival and demeanor were noticed by a housekeeper on the Driskill staff. Sensing something very wrong, the housekeeper phoned the woman's guestroom and urged her, "If you need anything, you let me know. You ask for me," and told the woman her name.

"Thank you," responded the guest, "but there's nothing you can do."

When the housekeeper noticed the Do Not Disturb sign still on the doorknob more than a day later, she became more concerned. She phoned the room; there was no answer and there was no response to knocking on the door. She alerted the management and they tried to enter with the master key but the door was locked from the inside. The door was taken off its hinges, and the housekeeper and security entered the empty room. The housekeeper was the first to see the bathroom door slightly ajar. Inside she could see through the mirror over the sink the sad truth behind the door.

After locking the door to her room, the woman had taken a pillow from the bed, faced herself in the bathroom mirror, and shot herself in the stomach, the gunshot muffled by the pillow. Her body lay partially in the tub, blood covered the floor.

Her name has been lost in time but her tragic decision to end her life in the room remains forever in the minds of those who saw her lifeless bloody body slumped on the bathroom floor. No one was affected more than the maid.

Today, after almost twenty years, she is still deeply saddened by the tragic death. In her memory and in honor of her spirit

Peter Lawless had an apartment in the Driskill for much of his life, and it is believed he is one of the Driskill ghosts today. *Courtesy of John Maverick.*

the housekeeper scratched a little cross into the glass of the window overlooking Sixth Street. There is evidence however that indicates something unexplained still remains in the Driskill's most haunted room.

Actually, relative to hotels in general, the Driskill has known very little death. So why are there so many unexplainable phenomena? Are the many spirits that roam the halls, ballrooms and balconies of this hotel perhaps captured in the flow of an underground spring? I believe the Driskill is so haunted because of all the life it has supported through time. Most of the people who worked at the Driskill did so for all of their lives, probably spending the majority of their lives within its walls. Ironically, the Driskill is haunted not because of deaths but because of life.

CHAPTER 9
THE HANNIG HAUNTING

In every country, in every culture for all of time, the concept of spirit or the disembodied energy that originated from a once-living being has existed. Rituals, customs and superstitions surrounding the end of life help us to feel some element of control over the one aspect of life that many fear: death.

We carry a corpse feet first, facing away from the mourners so the lingering spirit won't catch the eye of one of the living and beckon them to follow into death. Originally black was worn by undertakers, mourners and family members to be inconspicuous, so as to not draw the attention of the lingering spirit, lest it decide to take you along. It was considered a bad idea to interfere with the funeral procession leading the corpse to its final resting spot because it might impede the deceased's journey to the afterlife.

The black-haired, blue-eyed Susanna Wilkerson was originally from Tennessee and during her lifetime never learned to read or write. She married Lieutenant Dickinson when she was fifteen years old and he was thirty. Together, they moved to Texas. She was twenty years old when her daughter was born and twenty-one in March of 1836 when her husband died at the Alamo. She survived the battle at the Alamo and became known as the mother of the Babe of the Alamo. Twenty months later, she married again

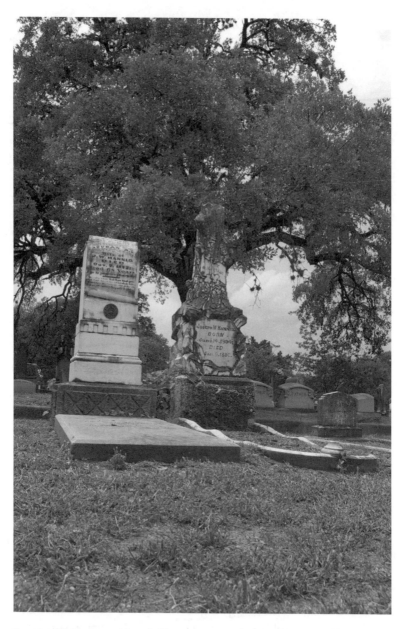

Susanna Dickinson and Joseph Hannig are buried next to each other in Oakwood Cemetery. *Courtesy of John Maverick.*

but divorced within four months, stating that her husband abused both her and her daughter. Nine months later, Susanna married another man. That relationship ended five years later when her husband died of digestive fever in the year 1843. Three years later, at the age of thirty-two, Susanna married her fourth husband. Ten years later, he would divorce her, accusing Susanna of adultery. They had been living separately for three years since 1853, before the divorce was final. Susanna married her fifth and last husband, Joseph Hannig, sixteen years her junior. They moved to Austin in the early 1870s after the death of Susannah's only child and remained married until her death at the age of sixty-eight in 1883.

In the 1800s in Austin, when your time was up and you were white, chances are your family would be doing business with Joseph Hannig at 204 East Sixth Street, his colleagues and family. He owned the premier furniture–undertaker business in town. If you were African American, you would be taken care of by the King establishment on East Sixth.

The process would start with a younger member of the deceased family knocking on the cabinetmaker's door to announce that a death had occurred. A Hannig family member would hurry over to the deceased's home with a measuring stick or string to determine what size to make the coffin.

Once the coffin was built, it needed to be transported to the home of the dead person. It was a somber and yet exciting time in Austin when the dead wagon emerged from the alley behind the Hannig building. Children were sent to follow the wagon to see where it would stop and find out who had passed on.

The cabinetmaker–undertaker would go to the home and bring along his cooling board or embalming kit, depending on the family's choice. After the funeral service at the home, a parade would ensue and proceed east on Sixth Street, north on East Avenue (Interstate 35 today), east again on Fifteenth Street and then into Oakwood, the city cemetery. Oakwood was founded on the highest hill east of Austin in 1839. Two men killed by Indians while digging post holes where Stubbs Barbecue is today

near the corner of Eighth Street and Red River, were the first to be interred. At Oakwood, the undertaker would have made arrangements with the gravedigger.

When we learned that the Hannig building was having some issues with ghosts, it was a natural leap to think it is because it is the old undertaker building.

The stories we heard were typical of all haunted locations and, surprisingly, nothing like what television shows and movies about ghosts depict. Contrary to what many have been led to believe, at least 90 percent of people who experience an encounter that they believe to be a ghost don't feel fear. Sure, they may have the "What the…!" reaction afterward, but that is fear coming from themselves rather than the experience.

Most of the haunting events in the building are not dramatic and are the typical three most common forms of a haunting. The first is the movement of an object; in the upstairs offices of 204 East Sixth Street, desk items are rearranged on a regular basis. The second most common form of a haunting is a smell. It begins and ends; it is clearly out of place; and you know when it happens. An inexplicable floral smell is common in the back rooms of the B.D. Riley's Irish Pub on the first floor of the building. The third most common form of a haunting is a feeling; the feeling you're not alone or the hair on the back of your neck stands on end. One of the managers who regularly opens B.D. Riley's Irish Pub—after unlocking the door and while walking to turn off the alarm—feels as though he is being watched and on many occasions can see out of the corner of his eye what looks like a man standing by the bar.

Who is haunting the Hannig building? Well, it is not any spirits related to the undertaking business.

Due to the massive numbers of dead bodies during the Civil War, a method was used to preserve the bodies so they could be transported to their respective homes; it was called embalming.

An incision was made under the deceased's upper arm and a tube inserted. The blood was drained and replaced with an arsenic and water mixture.

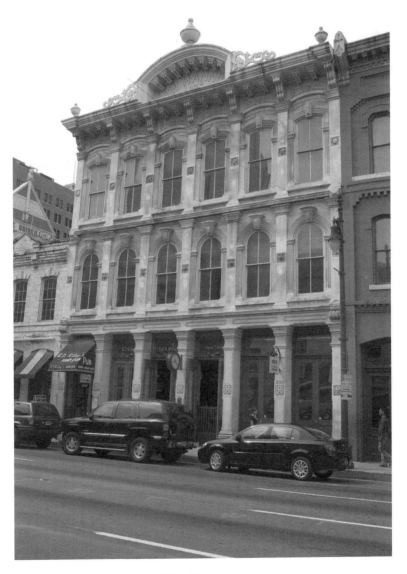

The Hannig building. *Courtesy of John Maverick.*

The back of the Hannig building. *Courtesy of John Maverick.*

The practice of embalming had begun in the North before the war. After the war, the Southern undertakers–furniture makers did not have the money or the resources to embalm. Consequently, traveling embalming salesmen from the North hit the Southern states like flies on a carcass. They targeted the business owners that dealt in death, such as the owner of the livery stable since they housed the dead wagon and the horses that pulled it. A dead wagon could be fancy or plain. Its purpose was to carry a corpse. It had to be well ventilated, so it had windows on all four sides. The salesmen also sought out the local owner of the cabinetmaker–undertaker business, like Mr. Hannig, because

they made the coffins for the deceased. The salesmen sold embalming kits that provided all the materials needed to perform the task: tubes, tools, and six glass bottles in what was called an embalming case.

Prior to embalming, a cooling board was used to hold the body before burial. A cooling board was a folding table on which the body was placed, with a block of ice put underneath. Holes were drilled into the board, and vertical handles could be pulled out on either side and used to suspend a cover over the body so that the ice and cool air could circulate around the body.

During most of the 1800s, all funerals happened in the home. The front room in the house or the parlor was where the funeral would take place—or in the person's bedroom if there was no parlor. Later, when people stopped laying out their dead in homes, these rooms would be called living rooms and the establishments where the funerals took place retained the name funeral parlor. Funeral parlors as we know them today didn't really emerge until the 1920s following World War I.

So while the Hannigs were in business, they were going to homes to assist in funeral preparations. Therefore, spirits haunting the Hannig building apparently are not from the undertaking business. Much of the bar and décor in B.D. Riley's was brought over from Ireland. Is it possible that a spirit was brought from overseas? Spirits can attach to objects. The Hannig building has had quite a few occupants since the undertaking business moved on. Could it be any one of those? The answer is, we don't always know who or why a building is haunted, just that it is.

CHAPTER 10
THE SERIAL KILLINGS OF 1885

Sometimes an event so horrific takes place at a location that it makes an imprint, and no matter what occupies that space in future years the home is never happy or the business never really thrives.

Through time, the memory of the violent event is lost but the residual energy that remains can be felt and affect us, though we don't know why.

In certain nondescript locations in downtown Austin, such as parking lots and parking garages where there were once neighborhoods, a residual energy shouts of blood spilled and justice unresolved.

From December 30, 1884, until December 24, 1885, six women, one girl and one man were brutally murdered. The murderer was never found. Except for old Texas newspapers on microfilm and the microfilm from out of town papers such as San Francisco and New York City, all recorded documentation of the murders was destroyed. Someone systematically culled through all city documents and eliminated any reference to murders that put the relatively small town of Austin, Texas, on the map.

Servant quarters in 1885 looked much like this building. *Courtesy of John Maverick.*

A Killer's Profile

The Victims' Connections

He was strong. In the early morning hours on the way to his victim's house, he picked up a hand ax, easy to find in those days. He entered the bedroom, hit any possible witnesses on the head with the ax, then bludgeoned the victim in the head, dragged her outside, cut her face and raped her. After each murder, the city bloodhounds arrived. Why the killings began, we can only guess. Why they stopped is just as much a mystery.

Following each slaying, someone was arrested. Whether they just looked guilty or had a tenuous relationship with the victim, it didn't matter. The arrests gave Austin's residents the impression that the local law enforcement was doing their job and handling the atrocities aggressively.

Each victim was a cook or related in some way to a cook. In the case of Mary Ramey, her mother was a cook; in the case of

Mrs. Hancock, her daughter was a cook. Three instruments were used: an ax, a knife and a long, thin steel or iron pin.

Twice the attacker would be seen. In both instances, it was by children, whom he never harmed. In fact, in the case of Elizabeth Shelly, he changed his pattern to accommodate the presence of children. He did, though, kill Mary Ramey, who was eleven years old. It is possible that she looked older for her age.

Austin would change irrevocably following this year of 1885. The reality of these senseless brutal murders would be for many years impressed upon this small town in Texas.

THE MURDERS

December 30, 1884—Mollie Smith

The murder of Mollie Smith took place on Wednesday morning, December 30, 1884, at 901 West Sixth Street, known then as Pecan Street.

Between 3:00 and 4:00 a.m., a Mr. Chalmers was awakened by banging and yelling at his front door. A neighbor and Mollie's common-law husband, Walter Spencer, was shouting that someone had tried to kill him. Rising quickly, Chalmers lit the oil lamp, turned the flame up and lifted the light to see the extent of Mr. Spencer's injuries. He saw four cuts on Spencer's face and a puncture wound beneath his eye. It was discovered later that the puncture had broken through the bone beneath Spencer's eye.

Dazed, Mr. Spencer could not tell what had happened to him. When asked where Mollie was, he did not know. The last time he had seen her was before falling asleep.

One can easily imagine what Mr. Chalmers was thinking. Had Walter Spencer been drinking, gotten into a fight and was now too drunk to know what was going on? Surely, there was an easy explanation for this strange situation. Never would he have

imagined the horror that had taken place the previous hour, right next door.

Mr. Chalmers called a hackney and sent Mr. Spencer to the home of Dr. Steiner, who lived at 304 Fannin Street. Spencer's wounds were treated and a piece of bone fragment was removed from inside of his eye. After his visit to the doctor, Mr. Spencer took another hackney to his brother and sister's house on 1511 Brazos Street. He told them what had happened and then, truly dazed and sick, fell asleep.

Mr. Chalmers did not live in the house next door to Mollie and Walter; he was visiting his sister and brother-in-law, Mr. and Mrs. Hall. Mr. Hall was an insurance agent with an office at 812 Congress Avenue. The Halls and Mollie lived next door to each other on opposite corners. The road set between their homes was one block west of the iron bridge that spanned Shoal Creek.

Mr. Spencer had just begun a steady relationship with Mollie. In fact, he had recently moved from a home he shared with his brother and sister to live with Mollie. She had been employed as the Hall's cook for one month. Mollie was not a native Austinite; she had lived only one year in the Capital City, having relocated from Waco. She was in her mid-20s.

When the sun began to rise, the Hall household began to stir and, at 9:00 a.m., they went to Mollie's house to investigate because it was getting late and no one had seen her. They found a broken mirror and much of the furniture knocked over. Blood was everywhere, including an ax that lay next to her bed. Where was Mollie? A neighbor was the first to find her, sprawled in the shadows between the back fence and the outhouse with most of her clothing missing. She had been outraged and there was a hole on the side of her head that went through her skull and pierced her brain. The trail of blood, more obvious now, led back to her bedroom door.

As news of the murder spread, city residents were appalled. This was the foulest deed Austin had ever seen. Such pointless violence had never occurred in Austin's history.

Spencer would later testify:

> *It was sometime between 9 and 10 o'clock at night Tuesday night that I went to Mollie's room. She complained of being sick and asked me if I felt sorry for her. She also asked me to wake her up early the next morning. I don't remember anything else that happened until I woke and found myself hurt. I don't know who did it, but it wasn't Mollie. I thought someone had killed me. Mollie was not in the room and I never knew her anymore. I went around in front of the house and woke Mr. Chalmers, and told him what had happened.*

Walter Spencer was arrested for the murder of Mollie Smith. William Brooks, a man Mollie had once dated in Waco, was also apprehended. Both were found not guilty and set free.

May 7, 1885—Elizabeth Shelly

Four months and seven days after the murder of Mollie Smith, thirty-year old Elizabeth Shelly was found on the floor of her bedroom with a two-inch-long gash over her right eye cutting through the cranium and exposing brain matter. A deep round hole was discovered just over her ear and another between her eyes, both penetrating her brain. In the room with Elizabeth, her three children slept. They were unharmed and had slept through the horror.

The theory is that the murderer entered the room, knew who he was looking for and went straight to Elizabeth, hitting her on the head and knocking her unconscious. Moving her to the floor, he then calmly inflicted the other injuries before raping her. Before leaving, he carefully wrapped her body in a blanket from the bed and again in a quilt he had removed from her trunk. Presumably this was done so that the children would not see her bloody body when they awoke. In the sand outside of Elizabeth's residence, which stood near the corner of San Jacinto and Third

Street (today a parking lot that belongs to the Whitley Company), bare footprints were found going to and from the house. They were described as short and broad.

All that day and into the night—and even the following day—people from all over the city crowded around the house. Morbid curiosity encouraged them to look at the spot where the horrific murder had taken place. Much of the discussion of onlookers must have centered on the lackadaisical response of the authorities. Even though the alarm was raised at 6:00 a.m., the city marshal did not arrive at the scene of the attack until after eleven o'clock, nearly six hours after the information had been sent out by Dr. Johnson.

On May 8, 1885, the front page of the *Austin Daily Statesman* read: "Another Woman Murdered in the Night by Some Unknown Assassin, Bent on Plunder. Another Night of Devilry in the Crimson Catalog of Crime."

The newspaper account of the crime follows:

When Dr. L.B. Johnson, a well known citizen of the city, went to market yesterday morning at 6 am, his usual time, he had no idea of the terrible tragedy that had been enacted on his own premises.

The doctor lives in a cottage on the corner of San Jacinto and Cypress Streets in the southern part of the city, the Central Railroad track being immediately in front of the house. Behind his house was the home of Elizabeth Shelly and her 3 children. The woman was employed by Dr. Johnson's family as a cook and had been in the service of the family for a long time.

On returning home he observed an unusual commotion. His wife met him in front and exclaimed "I believe Elizabeth Shelly has been murdered!" And it was so. Dr. Johnson's wife had sent her young niece to see where Elizabeth was. The child came back pale and excited, she had only taken a brief look in the room, but a glance revealed such an awful sight that the

child dared not enter, but ran quickly back. Her aunt had the same experience.

Hearing what the others had seen, Dr. Johnson ran around to the back of his house and pushed the door open to view a most ghastly sight. Stretched out on the floor with a gaping wound over her right eye, fully 2 inches long and nearly that wide. It was done with some sharp instrument, probably with a hatchet. There were several minor wounds that must have been done with some other weapon. There was a deep round hole just over her ear, and another between the eyes. The pillows were saturated in blood and the room was in great disorder."

May 23, 1885—Irene Cross

Twenty days after Elizabeth Shelley was murdered, not long after midnight, the killer struck again. Irene's house was behind Mrs. Whitman's on the northeast corner of San Jacinto and Seventeenth Street, just north of Scholz's Beer Garden. Her house had two rooms. In one room slept her young nephew and in the other Irene and her grown son. The son was out that night and she had left the door unlocked for him.

A *Statesman* reporter heard of the attack soon after it happened and accompanied Officer Brown to the scene. He reported in the third-person style typical of Victorian journalists:

Familiar as he was with repulsive sights, the reporter could not help being horrified at the ghastly object that met his view. The woman's right arm was nearly cut in two, from a gash over six inches long. A cruel cut extended over half way around her head, commencing just above the right eye. It looked as if the intention was to scalp her. She was moaning and writhing in pain.

The reporter asked the nephew what happened, and the nephew said the intruder was "a big chunky Negro man,

barefooted and with his pants rolled up. He had on a brown hat, and a ragged coat." The man came into the nephew's room and when the youngster began to cry out, the man told him not to scream, as he had no intention of hurting him. The man then went into his aunt's room and in a few minutes rushed out.

Out of all the women, Irene was not raped. She was able to fend off her attacker and scream loudly enough that he quickly abandoned his intent. Irene died from her wounds later that night and was buried the next day at Oakwood Cemetery.

August 30, 1885—Mary Ramey

Mary Ramey was the fourth and youngest victim. Between approximately 4:00 and 5:00 a.m. on the morning of September 1, the killer entered the home of Rebecca and Mary Ramey (sometimes spelled Raney). Immediately, Rebecca was "sandbagged" with a hand ax, leaving her with a gash about 3½ inches long above her right eye, a fractured skull and no memory of what happened to her. The killer then turned to eleven-year-old Mary. Of all the victims, she was the only one he did not have to hit with an ax in order to subdue. Dragged from the room, she was taken to the wash house. A sharp-pointed instrument was inserted through both of her ears, penetrating her brain.

Mr. Weed awakened suddenly because he thought he heard something in the yard. He roused his wife beside him, exclaiming that he had heard a "strange and unnatural noise." "It was probably a dog," she responded. There came another sound and Mr. Weed jumped from his bed and got his double-barreled shotgun.

The events of the morning soon became evident. Entering Rebecca's home, he found her bloodied and semiconscious with no idea of what happened.

Mr. Weed noticed that Mary was missing. It did not take him long to find her lying on the wash house floor, a small pool of blood beneath her head, and the obvious signs of having been

Most of the tombstones in the "colored green" did not survive through time, but the headstone of Rebecca, the mother of Mary Ramey, can still be found. *Courtesy of John Maverick.*

brutally outraged. He yelled to his neighbors to come out because two people had been murdered. One neighbor was told to stand by the back gate and not allow anyone in or out. Mr. Weed quickly saddled his horse and rode to the home of police sergeant Chenneville across from the Capitol. Fifteen minutes later, they were at the scene of the crime with the entire pack of city hounds.

In the meantime, Dr. Swearingen had arrived and was found sitting in the wash house talking softly to Mary. He remained with her until she died one hour later.

After returning to his home, Mr. Weed noticed the pool of blood beneath Mary's head was now much larger than when he left, leading him to believe that the crime had been committed just before she was found. Barefoot prints were discovered on the ground around Rebecca's house, in Mr. Weed's yard, through the alley and all the way to Mr. Evan's stable down the street. The dogs kept their noses to the ground all the way to the stable where they lost the scent. Again the killer had escaped.

Rebecca and Mary's home was behind Weed's Stables at the corner of San Jacinto and East Cedar Street. Today it is a parking area for the Railyard Condominiums.

September 28, 1885—Gracie Vance & Orange Washington

Gracie Vance and Orange Washington had lived together as a couple for quite some time. They were not formally married, but everyone treated then as such. Gracie was often referred to as Gracie Washington. On the night of September 28, Gracie and Orange had invited two women to spend the night as guests in their house. They were friends of Gracie and the three of them often spent time together. One of the women was Lucinda, nicknamed Cindy, who lived and worked a few houses up the street. She was employed by J.B. Taylor who, according to the 1885 City Directory, was a vegetable dealer. The second woman, Patsy Gibbons, lived a bit farther north on Whitis Avenue and was employed as Dr. Graves's cook.

When the killer entered the house, he was surprised to find two additional women sleeping in the room with Gracie and Orange—or had he been stalking Gracie and was prepared? Either way, he proceeded to give Lucinda and Patsy a blow to the right side of their heads, leaving a gas three and a half inches long on both of their foreheads. The *Austin Daily Statesman* called the wounds "lacerated and incised." Both injuries went through the skin, exposing and fracturing the skull. Lucinda would eventually heal. Patsy's injury, on the other hand, caused brain matter to seep through the broken bone, creating permanent brain damage. Orange Washington must have awakened and sat up during the two other attacks because he received a blow to the top of his head, rather than on the right side as the other two had. His wound exposed the bone and fractured his skull as well. But, in this instance, he was hit with such force he was killed instantly.

In typical form, Gracie's body was dragged from the house, in this case through the window rather than the door, and behind the stables. There she was outraged. The killer must have carried more than an ax because she had cuts and gashes on the right side and front of her face. The incisions ranged from one to three inches long. Her skull was not fractured. A bloody brick was found next to her head, and a watch chain with a small silver open face was found wrapped around her arm.

Unlike the other horrors, on this night, Lucinda regained consciousness and in a daze lit a kerosene lamp. The first thing that registered in her mind was the blood all over the room. The second thing that caught her attention was the man standing in the room. She recognized him. It was Doc Woods. "Don't do it, Doc," she exclaimed. "God damn you, don't look at me," he shouted before he jumped though the window on the west side of the house. Lucinda then ran to the closest neighbor Mr. Dunham. She found him awake and standing on the porch because he had already heard the disruption.

The neighbors were alerted. Within twenty minutes Mr. Duff and Mr. Dunham were in the yard with Patsy. Sergeant

All of the black victims of the Servant Girl Annihilator were buried in what was called "the colored green" in Oakwood Cemetery. *Courtesy of John Maverick.*

Chenneville and Officer O'Connor were on horses in front of the house with another neighbor Mr. Hotchkiss. Three doctors were on their way. At this point, a neighbor yelled from her second story window that someone was running from the stables heading west. Immediately, they gave chase, only to allow another escape.

Following these murders, a citizen's committee led by A.I. Woolridge offered a $3,000 reward to whoever found the murderer.

> Austin Daily Statesman
> *October 1, 1885*
> *In Front Of The Jury Of Inquest Mr. Dunham Testifies:*
>
> *I live at 2400 San Marcos Street. I knew Orange Washington and Gracie Vance or Washington. They lived together as man and wife.*
>
> *I was awakened by a noise. I heard someone passing my window going in the direction of the house occupied by these*

people. From the noises I took these people to be Gracie Vance and Orange Washington. They were laughing and talking and I heard them enter the house. I dropped off to sleep and was awakened by another noise in their house.

I took my gun and went to my back door. I heard 2 blows and a voice saying, "Don't hurt me." I said, "Stop the noise." The noise ceased, I then heard a gasping voice as if the mouth of the speaker was muffled. I waited a little while and hearing no further noise I locked my door and went back to bed again. I think I was asleep or nearly so, when I heard the breaking of a glass, as though a whole window had been shattered, and a woman screaming and running past my window. I took my gun and went to the front door and heard the sounds of blows outside of my yard. I think they were from 6 to 10 feet from the northwest corner of my fence on the outside.

I could not see them immediately I said "Stop that or I'll shoot" or words to that effect. The struggling ceased immediately, the girl Lucinda ran through the gate, directly to me and I heard the steps of someone running north on San Marcos street, as well as I could judge.

As the girl came to me she said "My God, Mr. Dunham everyone has been killed." She was in her nightclothes, which were bloody. I asked her if she was hurt, she said, "No, but my friends are all dead and Doc Woods did it."

On September 29, 1885, according to the *Austin Daily Statesman*, Doc Woods stated that he was at Mr. Baird's farm, which is eight miles outside of Austin, that Sunday night and Monday morning. He claimed that he did not leave there until the city officers brought him to the jail. Mr. Baird testified that Doc was at his place at 10:00 p.m. Sunday night and 4:00 a.m. Monday morning, at which time Doc was awakened by Mr. Baird. They ate breakfast and went to work. Other residents on the farm witnessed the presence of Doc Woods as well. He could not prove though where he was between the hours of 4:00 a.m. and 10:00

p.m. To the *Austin Daily Statesman*, Doc said that he had only met Gracie Vance and Orange Washington six months earlier and was not well acquainted with them. This statement contradicted a statement made by Lucinda that Doc Woods had stopped by Gracie's house a few days prior to the murders and asked if he could spend the night.

The paper stated, "Within the last few days, however, very serious doubts have been entertained as to the guilt of Woods." This statement refers to Woods's advanced stage of syphilis. Not only did it explain the bloody clothes he was wearing, but local doctors claimed that there was no way he could have outraged a woman. Another point that favored Doc Woods's innocence were the witnesses who saw him on the farm three hours before the perpetration of the crime that took place eight miles away. He was released.

December 24, 1885—Sue Hancock

The newspaper headline the day after Mrs. Sue Hancock was murdered read: "THE DEMONS HAVE TRANSFERRED THEIR THIRST FOR BLOOD TO WHITE PEOPLE."

Mr. and Mrs. Hancock slept in separate bedrooms in their house at 203 Water Street. Today, Water Street has been renamed Cesar Chavez. The location of the house is where the Four Seasons Hotel parking garage now stands.

On Christmas Eve night just after 11:00 p.m., Mr. Hancock woke suddenly from a deep sleep with the feeling something was wrong. Wondering if the house was being burglarized, he put on his pants and went to his wife's room. There he found blood all over the bed and his wife was gone. He exited the back door of the house and found his wife lying in a pool of blood.

He began screaming to his neighbors to come over, and he attempted to pick Sue up but instead sat down with her in his arms until his neighbor Mr. Percinger arrived and they carried her into the house. There they discovered she had been hit

twice on her head with an ax that was found on the scene. Her skull was fractured and blood was oozing from both her mouth and ears.

The couple had two daughters who were at Christmas Eve parties. The Hancock couple had left the door unlocked, waiting for their return.

The *Daily Statesman* from December 25: "While still gathering notes, absolutely kneeling by the side of the evidently dying lady, a shrill voice from the study cried to the reporter that another murder had been committed in the second ward, on the premises of Mr. James Phillips."

December 24, 1885—Eula Phillips

Mrs. Phillips, the wife of a well known architect living at 806 West Hickory Street, was awakened by the cries of her young grandson. Her son, James Phillips, with his wife and eighteen-month-old child, occupied a room across the hall. Mrs. Phillips, the mother, had been in her son's room only an hour before. She lit the lamp and crossed the gallery porch adjoining the main house with an adjoining wing. As she answered the baby's cries, a horrible sight met her gaze in her son and daughter-in-law's room. The unharmed little boy, who had been sleeping between his parents, was standing up on the bed, his night clothes crimson with blood and holding an apple. The youngster's father lay in a stupor with a gash in his head and neck. James's wife, Eula, was missing, her pillow bloody and the covers thrown back. A bloody trail was found leading on to the gallery, then through the back yard and next to the outbuildings. Eula's lifeless body lay in a pool of blood, nude. Across her bosom was a heavy rail, pinning her arms down. She had been dead perhaps half an hour, struck in the forehead with an ax. The skull was broken and she had been outraged.

The elder Mr. Phillips was quoted in the *Austin Daily Statesman* that "while this most horrible crime was being committed

Mrs. Phillips died soon after her son was found not guilty. *Courtesy of John Maverick.*

everything was as silent as usual." The paper continued: "No outcry seems to have been heard, so skillfully did the inhumane butcher or butchers carry out a crime worthy of the imps of hell."

Within a few hours, Austinites faced the most somber Christmas morning they had ever experienced. A Christmas Day meeting was quickly summoned at the call of the mayor. Gathering in the Hall of Representatives at the Capitol, a diverse collection of race, occupations and levels of society assembled as equals in a common cause: find a way to stop the killings.

Governor John Ireland thought it would be a good idea to set off all the fire alarms after each murder. Then armed citizens should run from their houses and hold their positions on corners and in alleys so the killer could be trapped. Another suggestion was to have a curfew. No one would be allowed out after dark, and if they were, they would have to answer to the armed patrols set up every few blocks. Another idea was to illuminate the entire city with giant lights.

The original proposition to erect the moonlight towers was due to the serial killings. *Courtesy of John Maverick.*

WHO WAS THE SERVANT GIRL ANNIHILATOR?

Moses Hancock, being detained as a witness before the jury of inquest, was prevented from being present at the interment of his murdered wife. Hancock was indicted but released on a minimal bail of five hundred dollars that, it was stated, was almost "a presumption of innocence." His trial began on May 30, 1887, and lasted four days. The verdict: not guilty.

James Phillips Jr. was put on trial for the murder of Eula. He was found guilty of Eula's death, but in November 1886, the court of appeals in Smith County reversed the decision. There

was also no evidence that either Hancock or Phillips were in any way connected with the deaths of the servant girls.

While it is doubtful that either of these men was responsible for the killing spree of 1885, it is equally dubious that two men, both of whom drank to excess, whose wives expressed dismay and fear for their safety, would commit copycat murders on the very same evening within a few hours of one another.

Was the killer apprehended for another crime? Did the public outcry for vigilance make it too dangerous to continue in Austin and he moved on? Was he himself the victim of disease or violence? The murderer was never named. No matter. When he breathed his last breath with blood on his soul waiting on the other side were seven angels. Did they meet him with mercy or justice?

BIBLIOGRAPHY

American Statesman, July 1, 1903.

Austin City Directory. 1871–1890, 1885, 1900, 1978.

Austin Daily Statesman, December 1884–January 1887; April 6, 1900–April 8, 1900.

Barkley Starr, Mary. *A History of Central Texas*. Austin, TX: Austin Printing, 1970.

Beryman, Swen. AF File. Austin History Center. Austin, TX.

Brown, Gary. *Texas Gulag*. Plano: Republic of Texas Press, 2002

Coffin, Margaret. *Death in Early America*. n.p.: Thomas Nelson, 1976.

Connor, Seymour, James Day, Billy Mac Jones, Dayton Kelley, W.C. Nunn, Ben Procter and Dorman Winfrey. *Capitols of Texas*. Waco: Texan Press, 1970

DeBartolo, Carmack. *Cemetery Research*. Cincinnati, OH: Betterway Books, 2002.

Duval, John C. *The Adventures of Big Foot Wallace*. Lincoln: University of Nebraska Press, 1936.

Fowler, Mike and Jack Maguire. *The Capitol Story*. Austin, TX: Eakin Press, 1988.

Frank Brown Journals. Austin History Center. Austin, TX.

Frantz, Joe. *The Driskill Hotel*. Austin, TX: Encino Press, 1973.

Hofheintz–Reissig. AF File. Austin History Center. Austin, TX.

Johnson, Mary Mowinckle, ed. *Oak Hill Cedar Valley Pioneers*. Oak Hill, TX: Oak Hill-Cedar Valley Pioneer Association, 1956.

Kemp, Willie. *True Tales of Central Texas*. Austin, TX: Firm Foundation Publishing House, 1979.

Layton, Christopher. *Commonwealth Institute of Funeral Services*, Houston Texas. Interview with the author, June 12, 2010.

Moncivais, Ramon. *Beneath The Shadow of the Capitol*. n.p.: E.C. Printing, 2006.

Newcomb, W.W. Jr. *The Indians of Texas*. Austin: University of Texas Press, 1961.

Oak Hill. AF File. Austin History Center. Austin, TX.

Parrinder, Geoffrey. *World Religions*. New York: Facts on File Publications, 1971.

Preece, Harold. *Swen Beryman, Texas Legless Hero*. Paper on file at Austin History Center, Austin, TX.

Schlereth, Thomas. *Victorian America*. New York: HarperPerennial Publishing, 1992.

Stocklin, Barbara. *The Texas Confederate Woman's Home: A Case Study in Historic Preservation and Neighborhood Conservation Planning*. Thesis, University of Texas, 1991.

Vance, Linda. *Eanes Portrait of a Community*. Dallas, TX: Taylor Publishing, 1986.

Waller Creek. AF File. Austin History Center. Austin, TX.

Wilbarger, J.W. *Indian Depredations in Texas*. Austin, TX: Hutchings Printing House, 1889.

Zesch, Scott. *The Captured*. New York: St. Martin's Press, 2004.

Please visit us at
www.historypress.net